The Birth of Art in Africa

Bernard de Grunne

The Birth of Art in Africa

NOK STATUARY IN NIGERIA

VILO

ADAM BIRO

The first edition of this book was published to accompany the exhibition *The Birth of Art in Africa – Nok Statuary in Nigeria* organized by the Banque Générale du Luxembourg.

ISBN: 2-87660-242-3

Printed and bound in Italy

TABLE OF CONTENTS

FOREWORD

The Banque Générale du Luxembourg was proud to bring to the public the prestigious and never previously attempted exhibition *The Birth of Art in Africa - Nok Statuary in Nigeria*. This event, the second of its kind focusing on African art, renewed the commitment of our bank as patron of the arts. Indeed, after a first and major exhibition on African masks co-organized in 1997 with the Musée Barbier-Mueller in Geneva, this second show was another exploration of the art of Africa which has been neglected for too long, even though it influenced all the major artists of the twentieth century.

The origins of art in Africa are still obscure. Nok sculpture exhibited and published in this catalogue is among the oldest witnesses of the artistic creativity of the people of Africa. Dating back more than two thousand years, these sculptures are the first signs of arstitic creativity in this part of the world. They astonish us by their refinement and expressive qualities. They also are a great illustration of sophisticated firing techniques as well as the artistic genius of Nok artists of that time.

The Birth of Art in Africa - Nok Statuary in Nigeria should be admired not only from an artistic point of view but also from the standpoint of archaeology and history. The first Nok pieces were discovered more than sixty years ago and they are the only witnesses left by populations that disappeared long before. Currently, only a few hundred Nok pieces are known and the study of their culture has just begun. This research is carried out by scholars of African civilizations such as Bernard de Grunne to whom the bank owes this exhibition. Thanks to his intimate knowledge of African art, he was able to reunite more than sixty of these masterpieces at the Banque Générale du Luxembourg.

On behalf of the bank, I wish to express our sincere gratitude and congratulate him for the results of his scholarly research. His work deserves our gratitude as it is not only the first time to our knowledge that a major exhibition on Nok art has been organized but also he has agreed to publish in this catalog the most recent scholarship on this civilization.

We would like to thank also the numerous Swiss, Belgian, French and German private collectors, who kindly consented to part with some of their best pieces for this exhibition. We would like to thank especially Marc-Yves Blanpain, who not only encouraged this project from the start but is a true collector and connoisseur of African art as well as a constant supporter of our bank.

The government of Nigeria offered its support to our bank for the organization of this exhibition. We wish to thank their representatives for their precious help and their open-mindness.

The bank is grateful to Jim Clemes who has realized the mounting of all of our exhibitions in the past few years with talent and great competence.

Let us not forget to thank the publisher Adam Biro which co-published with the bank the catalog which accompanied this show.

I would like to conclude by wishing as much success for *The Birth of Art in Africa - Nok Statuary in Nigeria* as for all our other undertakings.

<div align="right">

ALAIN GEORGES
Chairman of the Board
Banque Générale du Luxembourg

</div>

INTRODUCTION

The Nok civilisation in Central Nigeria, which produced the bulk of terracotta figurines for this exhibition, flourished between 900 BC to 200 AD. The artifacts covered a wide range of representations and manifestations in the social and economic life of the Nok societies that produced them, ranging from religion, remembrance, ceremonies and simple day to day art forms and animation. But above all, the artistic skill and excellence of that civilization have given some glimpses into ancient Nok societies' visual culture and sophistication therein.

While the artistic skills of the artifacts are unique for that civilization, the questions the indigenous terra-cotta pieces have raised remain largely unanswered. Enquiries and research into the art forms and civilization are ongoing toward providing answers to some of the questions.

No doubt, the terracotta from Nok has stimulated great international interest in Africa's cultural heritage. The Banque Générale du Luxembourg's response to this interest was to organize an exhibition as its own contribution to exposing and drawing attention to Africa's rich traditions. Apart from the exposition of heritage, the exhibition will no doubt facilitate business contacts and investment opportunities that exist between Europe and Africa. To this end, the exhibition was a catalyst for the promotion of international business. This is commendable.

Therefore let me, on behalf of my government and the business communities in Nigeria, register my sincere appreciation for organizing the exhibition.

P. B. ETA
Permanent Secretary
Federal Ministry of Information & Culture
Federal Government of Nigeria
Abuja

FROM ANCIENT TO MODERN NIGERIA

Human nature is such that we are rarely satisfied with superficial explanations of social and economic systems; we feel the need to dig beneath the surface to understand the roots of these structures, whatever the complexity and diversity of their development. The history of Nigeria, for example, is a formidable field of study, both for the diversity of its cultures and its ethnic groups; observers have been fascinated by the changing social trends that have occurred in the country. New scientific techniques mean that this curiosity can be turned into ever-specialized research, although it is still difficult to establish a reliable and definitive chronology in the sequence of movements of various tribes and social groups throughout this vast country; a sufficient number of undefined elements remain to interest future researchers. Today, however, solid evidence is appearing where once there was only obscurity, and we can, by using our imagination, guess how the Nok, Sokoto or Katsina societies, wich are twenty centuries old and more, were imbued with the arts and techniques of their often-distant neighbors, poor communications notwithstanding. Regardless of the aim of the artist—if there even was one, or if there was only one—the work mirrors the environment and pagan religion.

Today, Nigeria counts over one hundred million inhabitants and stands to be a major African power, though without threatening the territorial integrity of its neighbors. With a surface area of over six hundred thousand square miles, one-third of which is cultivated, the country has many natural resources (wood, tin, columbium, lead, zinc and others), although most of its economic resources now come from oil, situated around the delta of the Niger River, and its by-products. It is not, of course, the most populated or the largest African country, but its potential, combined with its geographic location, give it more interesting possibilities than other countries; this is why maintaining this country artificially on the fringes of the international community cannot be the best way to encourage its assimilation into this community.

The major migratory movements that began in this region around 3000 BC were probably triggered by a series of droughts and growing desert areas in the north. The more favorable climate in the south and the monsoons that provided water for seven months of the year made this a more hospitable land for the migrating populations; several movements toward the south probably occurred in subsequent years. There are no credible oral histories or written records, and it is therefore difficult to accurately reconstruct, much less date, these migrations, although it is probable that the population displacements were caused more by wars than by a search for food supplies.

We are certain that a multitude of reciprocal influences existed, creating a rich source that influenced all of Nigerian art. We can ignore the artificial boundaries created by the European powers in 1884-1885, a development that resulted in the disappearance of the great Yoruba people.

What else, other than these shared influences, would explain the presence at Igbo-Ukwu of extremely skillful, locally-produced bronze funerary objects,

which can be dated to the ninth century AD? How else can we interpret the discovery in these tombs of tens of thousands of glass beads, which must have come from Egypt or perhaps the Indian subcontinent?

It would be naive to portray the history of this country as a succession of events linked to climatic or military upheavals suffered by these people; nothing could be further from the truth. An analysis of the great state of Oyo in the southwest area of present-day Nigeria shows an administrative model with the existence of Alafin that had a tremendous organizational capacity, although it ultimately collapsed under the strain of managing such an immense power—similar to that of Rome and Egypt. Religious tolerance was a characteristic of Nigerian culture: the country was influenced by both the Muslim conquests, in the wake of earlier trading contacts, as well as by Christianity, whose god had been integrated into the local pantheon without the least ostracism in a remarkable example of religious syncretism, a contrast to many other places and times.

How, then, can we resist the temptation to demonstrate or rather reveal a few judiciously selected fragments of this remarkable two-thousand-year-old art, which carries messages and secrets for both the heart and eye, and which penetrate directly into the soul?

Kneaded by the artist, clay is the tool that freezes for eternity these faces which emerged from a long-distant past. They seem to be suffused with an inner light that radiates subtleties matched only by the diversity of different figures.

One cannot help being struck by the genius of these story tellers who turned from the lyricism of poetry and words to the more forceful medium of sculpture to convey their ideas.

Whatever their age and distance from us, these stories are still as vibrant today as they have been for succeeding generations of Nigerians; their impact on later societies, though unpremeditated and unforseeable, has been decisive.

A people with such a rich history and long past is certainly destined for a brilliant future.

The hospitality of the grand-duchy of Luxembourg, its inhabitants and the Banque Générale du Luxembourg, were the best guarantee for the success of this historic exhibition.

We thank them all for this initiative and their continuing dedication to the triumph of art in our world.

MARC YVES BLANPAIN
President of the Board of Directors
of the Belgolaise

NOK SCULPTURE IN NIGERIA

The terra-cotta statuary of the Nok culture in Nigeria is a classic art style whose sudden appearance has radically challenged the traditional art history of African sculpture, just like the great artistic tradition of the Olmec in Meso-America. The Republic of Nigeria appears to be the cradle of the first important tradition of figurative sculpture of sub-Saharan Africa. Human figures made in clay, whose size range from a few inches to almost life-size and which represent rulers, priests and high-ranking individuals covered with rows of beads and whose coiffures show both variety and audacity, were manufactured from around 1000 BC until approximately 1000 AD on the Jos plateau.

The history of art in sub-Saharan Africa challenges the notion of an organic evolution of art based on the study of Greek sculpture evolving from the highly stylized forms of Early Minoan styles into the classical formality of Phidias and Polykleitos fifteen hundred years later.

Early finds of Nok culture

Mining operations to open up tinfields in the lowlands south of the Jos plateau led to the first discovery of Nok sculptures. In the 1880s, traders of the Royal Niger company were buying tin ingots in the large trading centers of the Benue valley. Intrigued by the origins of these ingots, a pioneering expedition under the leadership of an English mining engineer, Henry William Laws, reached the traditional tin-mining areas and founded a flourishing tin-smelting industry on the Jos plateau centered on the highest point of the plateau, the Shere Hills.

This discovery of the geological origin of tin ingots accelerated the mining activities to exploit the deposits of tin ores concentrated into shallow levels of stream beds in a radius of approximately ninety-three miles around the village of Nok, inhabited by a population of the Ham ethnic group.[1]

These mining operations often led to the discovery of archaeological remains such as stone tools and fragments of terra-cotta figurines which would be given to the owners of the mining concessions by local miners.

The first discovery of a terra-cotta sculpture happened in the village of Nok in 1928. Colonel J. Dent Young, co-owner of a mining partnership in the Jos region, noticed a well-fired anthropomorphic head, four inches high, representing the head of a young child.[2]

In 1942, a superb head with a cascade-type headdress, one of the great masterpieces of Nok art, was found under ten meters of alluvial deposits at the site of Tsauni, in the hills above the village of Jemaa. This discovery named the "Jemaa Head" was reported by a mining engineer, Mr. F.H. Townsend to Bernard Fagg, a cadet administrative officer with archaeological training.

Bernard Fagg understood quickly the archaeological importance of the discovery some forty miles apart of two heads which were clearly stylistically related. Three more terra-cotta fragments were discovered between 1943 and 1945. These new discoveries were referred by Bernard Fagg in the first of numerous articles as the "Nok Series".[3]

He immediately alerted all those who worked in the minefields, showing them the Jemaa head as an example and he sought to gain their cooperation in reporting and preserving any artifact they would find instead of destroying by superstition or ignorance. Indeed a large number of Nok pieces were destroyed, whether inadvertently or voluntarily through the superstition of the miners themselves.

Yusufu Potiskum, a foreman who worked at Nok, was sent with an open letter on a tour of all the mines. A rest house was established to centralize all finds and an area was designated in 1947 by the Lieutenant-Governor's office as an "archaeological reserve." The collections of this small local museum increased in the next few years.

In 1951, a school teacher in the village of Katsina Ala, more than one hundred and twenty-four miles south east of Jemaa, decided to build a new hockey field. This entailed the felling of an old shea tree and when the stump was removed a collection of terra-cotta fragments, including twenty-eight

fragments of a seated figure and an elongated head with a mandarin-like moustache, were found.[4]

Further excavations on this site a few years later allowed the discovery of three other large human figures, each seated on a hour-glass shaped stool.[5] Four more heads were also discovered at a later date. Another head unearthed in 1955 on the site of Kagara extended this distribution almost one hundred and twenty-four miles north west of Nok.[6]

The discoveries extended the geographical distribution of Nok art much further south and north than the original findings. Many more terracottas were discovered in the next twenty years but the geographical distribution of the Nok style as defined by Fagg remained the same: the majority of pieces were found in the vicinity of Jemaa and Nok.[7]

Bernard Fagg understood the importance of these finds. He was the first to publish artifacts discovered in this region and he suggested the name Nok culture. He became the foremost expert of Nok art and spent his life researching Nok art.

In the spring of 1952, he inaugurated the new national museum housing all of Nok material in the town of Jos.[8] When Fagg published his complete survey of Nok art in 1977, he illustrated one hundred and fifty three objects which belonged to the collections of the Jos museum.

Numerous unpublished Nok sculptures have surfaced in the past ten years. Their discovery was probably caused by the opening of new mining activities in the Jos region as well as further north in the Katsina and Sokoto regions. These recent discoveries on the art market in Europe and the United States have opened new ways of research in the the history and evolution of Nok art.

The purpose of this essay is not only to enjoy the beauty and refinement of Nok sculpture but also to try and better understand the early art history of Nigeria by combining an art historical approach with scientific dating methods such as carbon-14 and thermoluminescence.

The archaeological context

Out of the one hundred and fifty-three pieces published by Fagg in his 1977 study, only one, a fragment of a torso, was found in situ in an archaeologically undisturbed context properly excavated.[9] All other one hundred and fifty-two pieces were chance discoveries found in the unreliable alluvial settings of tin mining activities. The majority were found at a depth of between fifty-nine and three hundred and ninety-four inches. In this type of environment, archaeological excavations are very difficult.

Indeed, the identification of associate finds with the terracottas is impossible since some of the material may have been derived from earlier deposits. Caution was also required by the fact that objects of very different ages can be mixed together by flowing water and end up in the same alluvial deposit. Axes and other objects made of iron were mixed with terra-cotta fragments as well as stone artifacts such as lip, nose and ear plugs made of quartz in the alluvial deposits.

Despite this difficulty of finding terra-cotta sculptures in a secure context, one can draw certain conclusions concerning the five Nok sites which have been excavated or prospected.

Let us review chronologically the results of these excavations.

The first archaeological excavation was the iron working site of Taruga, conducted by Bernard Fagg during three campaigns.[10] This excavation is crucial for the understanding of Nok artifacts since during the excavations Nok terracottas were found in association with iron working.

Two female headless terra-cotta figures seated on hour-glass shaped stools, their hands holding their breasts, were found in 1960 by miners prospecting for tin.[11] This discovery led to Fagg's first campaign of excavation in 1961. During this excavation, he discovered numerous objects of wrought iron, a quantity of iron slag, fragments of nozzles, a large quantity of domestic pottery, and pottery graters but no terra-cotta figures. However, a fragmentary head dated by thermoluminescence to 300 BC was found in a stream bed near the excavations.[12]

On his second campaign, he found thirteen smelting furnaces. Fragments of a large human terra-cotta torso and a miniature Janus figurine were discovered but we have no information on their stratigraphic context since the complete report still awaits publication.[13] A third campaign lasting from December 1967 until January 1968 produced three C14 dates for the furnaces, ranging from 440 to 280 BC ± 100 years.

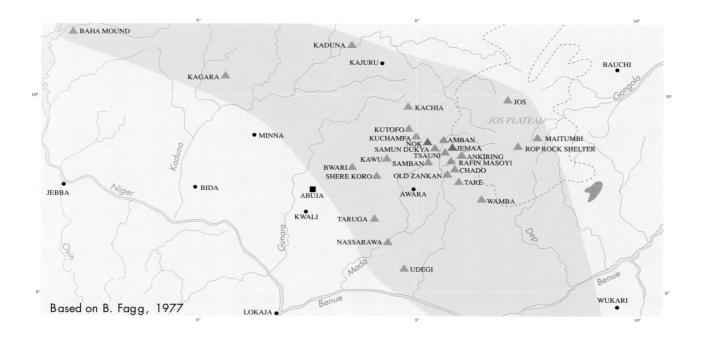

Map of the sites where the Nok sculptures were found

According to Fagg, his results at Taruga show that the site seems to be specialized in iron-working only, inhabited by blacksmiths and their families but there does not seem to be traces of permanent habitation with religious buildings.

The second site is called Yelwa. Excavations carried out in the area now flooded as a result of the building of the Kainji Dam on the Niger River in 1966/67 presented evidence from two salvage sites outside the Nok culture area. Both sites are near the village of Yelwa in the Sokoto Province. The first site was named RS/63/32 and the second Baha mound.

At the site of RS/63/32, an occupation mound dating from 100 AD to 700 AD, fragments of terra-cotta figurines in a provincial Nok style were discovered in association with stone implements and large numbers of iron objects.[14] Six heads were published later on by Willett.[15] One complete small figurine could belong to a peripheral Nok style with typical Nok eye and less refinement in the modeling. A statuette illustrated in this catalogue (p.99) could be related to this peripheral style of Yelwa.

Furthermore, four undisturbed tombs with funerary offerings such as iron bracelets and ivory jewelry were also excavated in mound RS63/32. No terra-cotta figurines were found in association with these burials, another indication that Nok-style figurines were not used in funerary in nature.

Baha mound, on the other side of the river, is dated between 200 AD and 900 AD. Only two heads have been published from this excavation: one is stylistically close to Nok while the second relates to an unknown style which is similar to figurines of a new style named Katsina, described further down in this essay.[16] Baha mound—now flooded—was clearly an important site for the understanding of stylistic ties and influences between Nok art and the new Katsina style.

The fourth site called Samun Dukiya was discovered by Fagg's daughter, Angela Rackham Fagg, herself a trained archaeologist. She undertook an excavation on this site, the only known ancient habitation site within the Nok region.[17] The site is dated between 1520 BC and 210 BC. Fragments of terra-cotta figurines were found in association with stone implements and

iron tools but the full results of her excavations still await publication.

The fifth and final site briefly excavated by J. F. Jemkour, a trained Nigerian archaeologist in 1982/83, is Old Zankan, an abandoned village about twenty-five miles southwest of Jemaa. According to Jemkour, Old Zankan was essentially an important center of manufacturing of stone tools where he found fragments of Nok figures on the surface, remains of an abandoned shrine and modern burial sites. Reports of the earlier discovery in 1965 of important fragmentary Nok statues indicate that Old Zankan was probably an important Nok site. It was Neolithic and related essentially to the manufacturing of stone tools since no traces of iron were found.

The main contribution from the five excavations and numerous chance finds by miners is a fairly precise geographical distribution for Nok art.

Out of the one hundred and fifty-three pieces published by Bernard Fagg in 1977, one hundred and fifty were found on an actual site. By comparison, according to my study on three hundred and ten ancient Jenne terra-cotta statues from the Inland Niger Delta, the geographical distribution of this art style was based on only thirty-five sculptures found in situ.

Another conclusion from the excavations is that no Nok terracotta has been found in a funerary context whether in a tomb or in association with human remains. None of the publications of Nok excavated sites mentions the presence of human or animal bones during the excavations. This characteristic is quite similar to the results of my research on Jenne terra-cotta statuary.

Unlike some of the Chinese terra-cotta sculptures, it appears until further evidence that Nok art is not funerary. Nok sculpture was used in religious ceremonies in a shrine context or in sacred houses or temples.

After the discoveries of Taruga in 1969, scholars have generally agreed that Nok sculptures belonged to an iron-working culture and were not part of a Neolithic environment. The discovery of a two thousand five hundred year-old culture mastering the iron technology appeared revolutionary at that time. Taruga was at the time the oldest iron-working site in sub-Saharan Africa. Recalibrated dates on Taruga have pushed the dates even further

back, suggesting an occupation from 805 BC until 25 AD.[19] Since then even older dates have been found in the Republic of Niger.[20]

The evidence points however to a Neolithic tradition in the majority of sites associated with Nok sculpture where large numbers of polished stone axes, adzes and stone arrow points were found.

We should also keep in mind that on the site of Nok, stone adzes were discovered ranging in age from the Early Stone Age (37,000 BC) until the end of this first millennium[21]. A site like Old Zankan where a number of fragmentary figures were found was exclusively used for the manufacturing of stone tools.

Therefore, it appears that Nok terra-cotta figures clearly belonged to a Neolithic environment which only gradually moved to iron work. Iron seems to have been introduced around 400 BC in a continuum similar to the situation noticed on the site of Daima (also in Nigeria, but further east towards the border with Chad) with a slow continuum from 600 BC until 1100 AD from stone-age to iron-age technology.

The Nok culture evolved towards an iron-using culture, maybe on a small scale since many stone tools were used for a very long time after this invention. This revolutionary technological change may not after all have played such a major influence on the Nok people and their culture.

Chronology of Nok art

One cannot talk about art history without a chronological framework. Stratigraphic work researched during excavations only gives us a relative chronology. Radiocarbon and thermo-luminescence dating are two scientific methods that have greatly helped archaeologists and art historians in their efforts to date works of art.

The radiocarbon dating system depends on the following principle: every living thing is composed of fixed proportions of carbon in two forms, carbon-12 which is inert and carbon 14 which is radioactive. When a living organism dies, its radioactive carbon begins to decay. It takes five thousand seven hundred and thirty years for half of the radioactive carbon to decay. It is thus

possible to estimate when the organism died by measuring what proportion of carbon 14 is left in a sample of the deceased organism.

This method, invented in the 1950s has improved notably in the past twenty years. Researchers have noticed that carbon-14 does not decay in a steady manner but proceeds in fits and starts. It became necessary to recalibrate all the carbon-14 dates obtained in the fifties and sixties. This recalibration has affected the chronology of Nok art since many C14 dates were done between 1957 and 1970.

Concerning the general chronological framework of Nok art, the uncalibrated dates proposed by Bernard Fagg ranged from 500 BC until 440 AD.[22]

Recent recalibrations of C14 dates have extended the periodization of Nok culture: it started earlier, around 900 BC, and extended until 875 AD.[23]

One should also not dismiss entirely two dates that are even more recent. The first date at the site of Katsina Ala ranges from 1450 AD to 1630 AD and the second at the site of Taruga extends from 1650 AD to 1795 AD.[24]

Map of the ancient civilizations of Nigeria

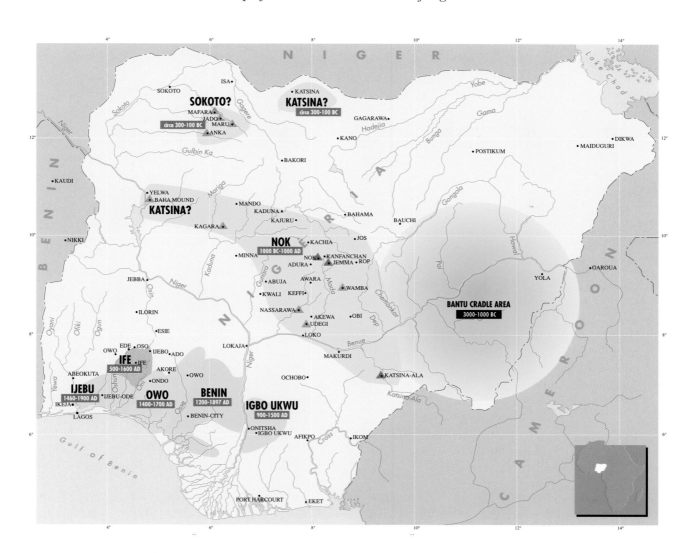

These two dates were considered by Fagg as aberrant. However, just as with terra-cotta statues in the Inland Niger delta region in Mali, the two dates suggest that populations living in the more remote areas of Nok culture in the stricter sense could have continued to occupy these Nok sites even after they ceased to create or worship the terra-cotta statues.

Three other very early dates from the site of Nok, ranging from 4580-4290 BC, imply that the site of Nok has been continuously occupied for more than five thousand years, starting at the time of the early proto-Bantu dispersal around 3000 BC.[25] We shall refer the reader to that part of the essay further down.

Radiocarbon dates measure the age of organic objects found in the stratigraphic vicinity of terra-cotta sculpture but not the date of manufacture of a terra-cotta figure itself. In contrast, thermo-luminescence dates are derived directly from the time of manufacturing of terra-cotta sculptures.

More than twenty Nok sculptures have been tested by thermoluminescence. The first piece to be analyzed by the laboratory of Oxford University where this method was pioneered was the Jemaa head: the date obtained was 530 BC ± 200 years.[26] The archaeologist Jemkour has published a chart with 23 dates of Nok pieces: their age ranges from 555 BC until 570 AD.[27]

I will refer the reader to the essay by Maurer and Langevin in this catalogue concerning this technique (p.111). Their conclusions are based on a new approach of cross-dating objects. Some large Nok sculptures were built with internal wood structure that was carbonized during the firing of the clay. By dating both the C14 remains of the carbonized wood inside Nok figures and the clay by thermoluminescence, one gets a more accurate chronology. Their conclusions seem to push back the birth of Nok art another five hundred years, to 1000 BC.

Techniques of manufacturing of Nok sculpture

Except for some miniature pendants which are solid, all Nok sculpture made of terracotta are hollow. The handmade figures are coil-built with local clay mixed with a gritty material made of decomposed rock gravel with small inclusions of quartz.

In certain sculptures, the head is modeled as a separate solid piece and then luted into the neck of the hollow figure.[28]

Sometimes the limbs and heads were modeled separately and much of the surface details—tresses of hair, beads, necklaces and bracelets—were made and then applied to the main figure. A smooth final surface was achieved by applying a slip of ochre or decomposed mica schist in solution then burnished with a smooth pebble.

Some of the large-size statues were constructed with an internal wooden armature in order to strengthen the soft unfired clay. A central branch would support the entire torso with lateral projections towards the limbs and the head. This wooden inner structure would be carbonized and destroyed during the firing process.

The iconography of Nok art

The careful study of all preserved Nok sculptures is the basis for a definition of the Nok style. One should however keep in mind that an unknown and certainly important number of Nok sculptures were destroyed by mining activities. Our definition of a Nok style is founded on a limited class of forms.

Four main characteristics distinguish the Nok style. The first is the treatment of the eyes, which form either a segment of a circle or sometimes a simply triangular form, with the eyebrow above balancing the sweep of the lower lid, sometimes making a circle. The second distinguishing feature is the piercing of the pupils, the nostrils, the lips and the ears. A third characteristic is the interest shown by Nok artists in the careful representation of elaborate hairstyles, with complex constructions of buns, tresses, locks and the profusion of beads around the neck, torso and waist. The last feature is the realism in the modeling of the curled lips, the straight nose with flaring nostrils and the large overhanging forehead.

As mentioned earlier, the nucleus of the Nok corpus is the one hundred and fifty-six objects analyzed by Fagg in his book published in 1977.

Since then, the appearance on the art market of many new unpublished pieces is a unique opportunity to enrich our knowledge of this important artistic tradition.[29]

We have been fortunate to examine personally a number of sculptures and fragments and have access to numerous photographic archives. The enlarged corpus of study on which our research is based amounts to approximately four hundred pieces. Our conclusions based on this new material are subject to change in the future as new research and discoveries are made.

These discoveries of the past twenty years include a number of complete figures that show a variety of gestures not available when Fagg did his research. We have summarized this research on new gestures in a chart with seventeen new attitudes and poses.

The first criterion of classification for this chart on Nok gestures is the attitude or posture of each figure refering to various positions of the entire body such as standing, seating, kneeling and crouching. A second criterion differentiates between gestures of the limbs and head.

Based on a corpus of three hundred and seventy-four photos of Nok works of art, we have noticed the following postures.

1. Standing figures: 149 sculptures or 40%
2. Sitting figures: 148 sculptures or 40%
3. Genuflecting figures: 76 sculptures or 20%

By limiting the criteria to the positions of the limbs, one can further differentiate between the following gestures:

1. Genuflecting
a. left leg kneeling, right leg bent vertically against torso: 23 statues
b. right leg kneeling, left leg bent vertically against torso: 53 statues

2. Seated
a. hands crossed on kneecaps, head resting on hands: 85 statues
b. head resting on kneecap of bent right leg: 32 statues
c. head resting on kneecap of bent left leg: 1 statue
d. seated, head held erect: 30 statues

One can also differentiate between male and female representations in Nok art by the presence of marked sexual features. For male figures, a penile sheath as well as moustaches or beards are clearly indicated. For female figures, the typical loincloth as well as naked breasts are clear indications.

Taking into account only the complete figures where these sexual characteristics are still visible, we have noticed the following proportions:

150 male figure or 63%
91 female figures or 37%

Using the sexual differentiation within the various postures, one can note the following conclusions:

1. Standing figures: 52 female figures or 86%, 8 male figures or 14%

2. Seated with head held erect: 17 female figures or 70%, 7 male figures or 30%

3. Seated, head resting on hands: 85 male figures or 100%

4. Seated with head resting on kneecaps: 34 male figures or 100%

5. Genuflecting: 76 male figures or 100%

The totals mentioned above do not match those used for the three categories of standing/seated/genuflecting since some of the statues were too fragmentary for sexual differentiation. As to the variety of coiffures, there does not seem to be any relationship between a certain type of coiffure and the sexuality of the person represented. A more detailed study of all known Nok coiffure could perhaps modify this final conclusion.

The study of all this unpublished material has led to two new and important conclusions on the iconography of Nok art.

Firstly, there is a two-thirds majority of representations of male as opposed to female images.

Secondly, certain gestures such as genuflecting or sitting with the chin resting on the knee cap

Different types of Nok penis sheaths

are the prerogative of men. Other attitudes such as standing seem to be attached to images of women.

The strands of beads around the neck, the hips or crossed on the chest probably represent stone beads made of polished quartz or metal beads in tin. Indeed, stone beads have been discovered by J. F. Jemkour during his excavations in Nok.[30] Some statues are decorated with representations of large pear-shaped beads. These large beads were probably originally cast in tin, since Fagg mentions the discovery of a stone mold used to make this type of bead.[31]

Another important new discovery is the presence on a number of statues of penis sheaths or aprons. In female statues, the aprons are represented in woven fiber with bead strands around the waist. This type of clothing was still used in the twentieth century by populations on the Jos plateau as illustrated by Fagg in his book.[32] Early photographs of Yendang women (p.52) taken by the anthropologist C. K. Meek in 1948 show this type of apron still worn on the Bauchi plateau, about one hundred and fifty miles east of Nok.[33]

As far as male statues are concerned, men generally wear a very visible penis sheath. There are various types represented: one is a cone widening in the lower part, the second a simple cylinder and a third a cylinder narrowing on the lower end. Again, this type of male attire was also photographed by Meek for modern Nigerian groups (p.34).[34]

Meek underlines the fact that among the populations of the Bauchi plateau, wealthy or important members of the group would be distinguished by the size and complexity of their penis sheath.[35] This remark could be applied ethnoarchaeologically speaking to the Nok population since the larger and more elaborate statues showing complex penis sheaths probably represent important figures, chiefs or other high-ranking people.

In a very interesting comparative study on penis sheaths in world cultures, the art historian Peter Ucko illustrates three woven penis sheaths from the Jos plateau which now belong to the Pitt-Rivers Museum in Oxford and remind us of those seen on Nok statues.[36]

Without being diffusionist, one can notice the following facts concerning the antiquity and distribution of penis-sheaths in Africa.

The earliest representations of this type of clothing appear on proto- and pre-dynastic Egyptian figures (around 3000 BC). A famous example is the MacGregor statuette from the Ashmolean Museum in Oxford, dated to 3100 BC.[37] This type of Egyptian penis sheath, called Bantu sheaths in the specialized literature, appear to be "Libyan" in origin, probably from the paleonegritic cultural substratum.

According to a map prepared by Ucko for his study, penis sheaths are centered around the nuclear protobantu dispersal center from Eastern Nigeria with a secondary flowering in the Bantu population of southern Africa. It would be interesting to explore possible connections between the distribution of penis sheaths and early Bantu populations.

Formal unity of the Jemaa style

Nok sculptures are found on a very large territory and the artistic tradition lasted over one thousand years. However, even after taking into account all the new discoveries, one can state the fact that there is a strong unity in every Nok piece and one can immediately recognize a Nok style. William Fagg already remarked that "the Nok ensemble is quite remarkable by the association of a great diversity in the conception of form with a strong unity of style, which allows us to realize immediately that two fragments belong to the same style, even if one appears to us to be naturalistic while the other is much more abstract, without becoming totally non-figurative."[38]

All these new discoveries seem to confirm the preeminence and high artistic level of the classic Nok style centered on the sites of Nok and Jemaa as it was first illustrated by the discovery of the Jemaa head in 1942. A chart established by the Nigerian

Fig. 1: *male statue with a penis sheath*

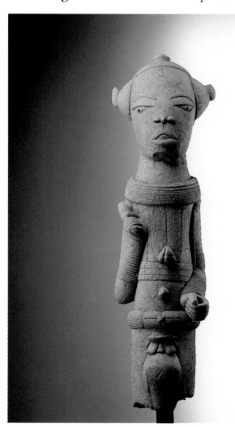

scholar Yashim Isa Bitiyong is quite revealing: 42% of all discovered pieces come from Nok and 30% and 30% from Jemaa.[39] These two sites which are only forty miles apart have produced 72% of all documented Nok pieces. We propose to name this style the classical Jemaa style.

An attempt to classify Nok sculpture stylistically by site using such basic units as the shape of the head—cylindrical, spherical or conical, the type of coiffure or the form of the eyes—seems to produce inconclusive results.[40]

The herm statues of Kuchamfa

Standing figures can be divided into two types: the first type represents a fully three-dimensional standing figure, while we propose to name the second type the herm-statue, in comparison to hermaic marble statues from Greek antiquity with a quadrangular pillar surmounted by the head of the god Hermes.[41]

In Nok art, this second type is instantly recognizable: the human body is rendered in a very simplified manner, in the shape of a simple cylinder, sometimes expanding at the lower end. Legs are not modeled, the feet sometimes appear at the extremity of the cylinder, the arms are set against the torso. The only part which is fully modeled is the head. Their height varies from twelve inches to thirty-nine inches. We shall call this type the herm-statues of Kuchamfa, Kuchamfa being the first Nok site where a fragmentary statue of this type was discovered.[42]

The Katsina Ala style

Another Nok style that shows a strong formal unity is the style of Katsina Ala, from the name of the site which was described earlier in this essay. It is in Katsina Ala that was discovered the first head of a particular type: the head is quite elongated in an almost cylindrical manner.

This elongation is a practical solution found by Nok artists to represent seated human figures with the chin resting on the raised kneecap. We have grouped in the catalogue all the statues and

heads that show this remarkable elongation and have named this group the Katsina Ala style. Other classifications based on the function of each type of object would also be promising but need further excavations.

The amulet figurines

The amulets are basically miniature representations of larger-sized Nok statues. They are generally perforated in the back for attachment. A full-size Nok torso illustrated here with such an amulet hanging from its neck is proof that these small pendant statuettes were carried by Nok people. (Fig. 2)

These objects were probably used as periapts or amulets and traveled with their owners. They could also be symbols of office for religious figures. Similar terra-cotta amulets were equally found in the artistic tradition of the Inland Niger Delta in Mali. According to my informants in Jenne, their purpose was to be used as portable altars while traveling.

Another hypothesis on the use of these amulets would be that they were miniature reproductions or a sketch of larger figures just as a modello for an artist of the Italian Renaissance. The Renaissance modello was a reduced model made in bee's wax, clay, wood or marble, in order to visualize the effect of a large-size sculpture.[43]

The amulets or modelli could have been carried by traveling Nok artists as mnemonic devices. A wooden modello of a Epa mask- generally a sculpture up to fifty-nine inches high illustrated here (p.84) seems to substantiate this hypothesis. The existence of such modelli could explain the wide distribution of an "international Nok style" during more than one thousand years throughout such a large territory.

Functions of Nok art

We have very little data on the use and function of Nok sculpture. Archeological excavations seem to indicate that a funerary function with statues buried in the tombs of important people is highly unlikely. Since archeology is extremely difficult in the type of alluvial terrain where Nok art is found, one could attempt to work backwards with the help of ethnoarchaeology.

The Nok statues are clearly images of dignitaries: kings, queens, priests, diviners. These images were surely worshipped in sacred shrines. We have reconstructed a Nok temple (p. 25) using photographs of traditional Ibo altars with seated figures in clay as well as sacred altars of Ife and Benin. In the drawing, we have alternated both seated and standing Nok statues on the side walls surrounding a central altar hypothetically with statues of a king, queen or other important cultural heroes, heads of clan or founders of village based on information on the Nok site of Old Zankan. This drawing is of course theoretical and new discoveries may radically change our views on this matter.

The Sokoto style

In 1992, the art market saw the appearance of a group of terra-cotta figures in a style distinct from the Nok.[44] A group of ten pieces supposedly excavated from the region of Karauchi, more than 400 km from the center of Nok art, was published.

Other chance discoveries of Sokoto sites were noticed from the region around the cities of Jado, Maru and Anka, caused apparently by oil prospecting in that region. According to Frank Willett, the style corresponds to a peripheral Nok style dated from the first millennium AD.[45]

This style is called the Sokoto style because it seems that they originated from the northern Nigerian state of Sokoto.

Formally, the style is instantly recognizable from a classic Nok sculpture. The eyes are treated in a very different manner. Although they are pierced with a circular hole like the Nok eye, both the eyelids and the eyebrows form a single heavy-set downward curve, underlined by thick cross-hatching, which give a severe look to the face.

Another important difference is the simplicity of coiffures and headdresses. The skullcaps are simple spheres reminding us of calabash used as coiffure by the Kirdi people at the border with Cameroon.

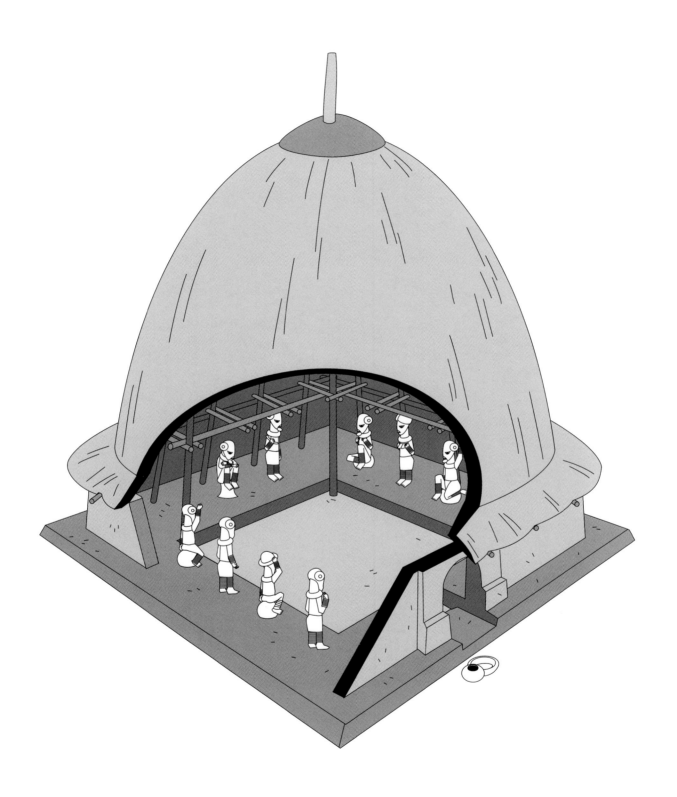

Theoretical diagram of a Nok temple.

We have no archaeological information on this new style and we can draw only provisional conclusions based on the study of photographic archives of about one hundred and thirty fragments of Sokoto pieces. According to the thermoluminescence dates, the style is dated between 200 BC and 200 AD.

The vast majority of Sokoto objects are human heads; very few show the torso or legs since they were probably broken or destroyed. Out of photos of one hundred and thirty heads, one hundred and fifteen clearly showed a beard and twenty-five were beardless, a proportion of 82% of beards for 18% beardless.

However, even if the beard is clearly a male physical feature, we cannot draw any conclusions about the gender of the beardless heads.

Among the bearded heads, we noticed the following percentages:

99 with a beard with one long point or 86%
5 with three-pointed beard or 4%
2 with four-pointed beard or 1%
5 with round collar beard or 4%

One finds also one maternity figure with a child on its lap and a few Janus figures with two pairs of arms and legs emerging from stylized cylindrical torsos.

We shall have to wait for future research on the new style. One final remark: the general feel of this style reminds us of Igala royal masks, a much later artistic tradition which goes back to the founding of the Igala kingdom around 1400 AD. The scarifications on these wooden masks were influenced by Ife customs.[46] This formal similarity between Igale helmet masks and Sokoto heads could be coincidental but should be investigated.

The Katsina style

A second style dated from the same period as the Sokoto style seems even more peripheral. The human figures in this style always emerge from the top of globular jars, their body barely modeled with small limbs.

The few complete statues show an identical position with diminutive bent knees, hands resting on the kneecaps. Unlike the complexities of Nok hair, coiffures are simple spherical skullcaps. The eyes are also treated in a very different manner from the Nok: they are basically a long horizontal slit below overhanging eyelids.

The average height of a group of twenty-one complete statues is nineteen inches and the tallest one measures twenty-six inches. One should also underline the absence of any form of beadwork or jewelry. A few Janus statues have also appeared.

We have no precise geographical provenance on this new style. However, a torso found near the Nok site of Jemaa shows some resemblance in the simplicity of the modeling of the limbs to the style.[47]

Another head found on the Baha mound near Yelwa shows also some formal similarities, especially in the treatment of the slit eyes.[48] I have marked both Katsina in Northern Nigeria and Yelwa on the map as two possible areas for this style.

The head of Katsina style statues is the only part which shows sensitivity in the modeling. They almost feel pre-Ife in their realism. Could the Katsina style be a Pre-Ife style? Further research will undoubtedly shed new light on this new style.

The Nok Avian king: a case of Shamanism in Nok art

This Nok statue representing a half-human half-bird figure (p.92-93) is a remarkable composite creature, a mythological beast or dragon created as an amalgamation of human royalty with avian characteristics. It shows a bird-like body, with a human head and neck, legs that look like human arms as well as five human fingers and an up-turned thumb that look like claws of birds of prey.

The human head of this figure is quite remarkable: the facial features are typically Nok in style especially in the treatment of the eyes, eyebrows, nose and coiffure.

The mouth of this composite sculpture is not human. It is transformed into a bird's beak, maybe an egret, a kingfisher, a vulture or a white-tailed ant thrush (*Neocossyphys poensis*).

The coiffure resembles a multifaceted skullcap (eleven facets on the lower part, nine above and three on top of the cap) and each facet is pierced

in its center possibly for the insertion of bird feathers. One finds a similar type of cap among Yoruba kings, who always decorated their crowns with egret feathers.[49]

Numerous beaded necklaces adorn its torso. The presence of beads symbolizes a royal prerogative which is found in the latter artistic production of Ife and Benin. Beaded crowns with birds are also part of the royal regalia among the Yoruba. Indeed as Thomspon has demonstrated, the presence of beads is a divine prerogative attached to the representations of gods and those who communicate with them such as kings, priests, diviners.[50]

This sculpture reminds us of numerous jade figures of were-jaguars carved by the Olmec. The complex iconography of these marvelous statuettes is deeply connected with shamanistic rituals.[51]

Shamanism is not strictly speaking a religion but a set of ecstatic and therapeutic methods whose aim is to communicate with the invisible world of spirits and seek their help in human affairs.

It originated in Central and Northern Asia (Arctic, Finno-Ougrien, Himalayan and Turkish-Mongol ethnic groups) and scholars now also include Korea, Japan, Indochina and the American continent.

Shamanism has played a vital influence in the art of certain Central and South American cultures. Shamanistic art of the Northwest Coast of British Colombia has been brilliantly studied by Allen Wardwell.[53] In Central America, the iconography of Olmec art has also been deeply influenced by shamanism.

One of the basic tenets of shamanism is the qualitative equivalence between human beings and animals. As Peter Furst indicates, "some of the themes of the Archaic circum-northern Pacific shamanistic substratum are the following: human-animal transformation, qualitative equivalence between humans and animals, ecstatic trance, guardian spirits and animal alter egos and journeys of the soul".[54] For instance, among the Olmec, a pervasive motif decorating their statues is the "flame eyebrows" symbolizing the harpy eagle or jaguar of the sky. Harpy eagles with their wings, claws and beaks are feared among many groups in South America as they are the only other

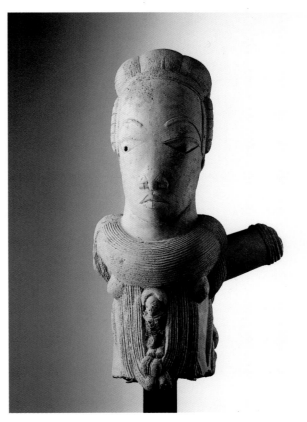

Fig. 2: *statue with an amulet figurine on his chest*

animal, the jaguar besides, capable of killing human beings.

Scholars have differentiated shamanistic practices where priests ascend towards deity, from ritual possession in Africa where gods descends on humans to "ride" them, such as among the Fon of Dahomey, the Yoruba of Nigeria and the Songhay in Mali.[55]

Whether one talks of the vertical ascent of man toward god or the descent of gods in human beings, both in Asian shamanism and African possession one finds powerful sculptural symbols of avian kings, feline priests, or snake kings that connect human beings with the three elements of water, earth and sky.

The symbolism of a mythological beast both human and avian is much rarer. The only parallel is a group of eight stone dragon figures with human features discovered in a sacred space behind the king's residence in the Eastern enclosure at Great Zimbabwe, the African

acropolis, dated between the nineth and the eighteenth century.[56]

The most elegant of these eight figures represents a bird of prey with wings folded back, a sloping body, with human lips rather than a beak and human limbs with four or five toes rather than three talons forward like most raptors. The scholar T.N. Huffman interprets them as images of defunct kings, the bird of prey being the messenger of god since it travels between heaven and earth. Apart from this group of eight statues, another famous example is the mysterious birdman from the Tishman collection.[57]

Looking at other cultures that also possess this type of iconography, one can notice the female winged lions, cruel and feared creatures such as the famous statue of the sphinx of the Naxiens at Delphi dated from 575 BC. Formally closer to our Nok figure, one finds deities such as sirens and harpies painted on Greek Attic vases with an upper body and head of a woman and sharp claws.[58]

In a fascinating article on traditional medicine in Benin City, Nevadomsky offers another explanation for the bird symbolism in Benin art.[59] He convincingly identifies the string beaked bird on the Yoruba medicine staff as the white-backed vulture (*Gyps bengalensis*), a large predatory bird over one meter tall and with a powerful beak.

Another interesting parallel of a human/avian figure is found on a Benin ceremonial stool with a rare representation of a priest attached to two Benin gods, Uwen and Ora. The human figure is represented with a long pointed beak symbolizing the cannibalism of the priest and links him to the dreaded powers of witches who transform themselves into night birds with long beaks to attack and consume their victims[60].

This Nok avian king is the powerfully executed fusion of the divine power of the king, suggesting both the splendor of royalty through the abundance of beads and its other more dangerous aspect—the king as bird of disaster—who has both the power and capability to kill his enemies.

One also finds representations of birds alone in other cultures, such as the bronze bird figures from Jenne, the large wooden bird figures among the Senufo and bronze roosters on Benin altars[61].

Other animals are represented in the Nok bestiary. Fagg had already published heads of elephants, monkeys and felines and snakes(p. 95-96). Recently, a statue of a large ape with a human head and two pairs of fangs sticking out of the mouth appeared on the art market[62]. All these anthropo-zoomorphs are mythological beasts or dragons as Joralemon has named them in Olmec art with hand-paw-claws, wings, fangs and avian and human body. They are representations both of a physical and metaphysical experience of rulers or priests in ecstatic poses when they transform themselves into birds of prey, lions, snakes and apes.

We have included in this catalogue statues of fish, felines and elephants, all animals that share a human characteristic, the classical Nok eye.

Polykleitos or the invention of a canon in Nok art

A comment on Polykleitos comes to mind when looking at Nok sculpture: "he understood the human body as a cosmos which consisted of small elements that were interrelated in spite of their different functions"[63]. The dimensions of a statue by Polykleitos could be reconstructed by using series of subdivided surveyor's rods, thus multiplying or dividing a single fixed unit.

Among the Nok, the metal rod could have been replaced by wooden ones and miniature statues or amulets with a normative set of proportions may have also served a mnemo-technic purpose to pass on this canon to other artists.

Panofsky already remarked that the history of the theories of proportions is the mirror of the history of styles[64]. The first historian to expand on this idea in non-European art is the prehistorian André Leroi-Gourhan who asserts that rhythm in a three-dimensional object comes from the repetition of an identical (or as he calls it "isometric") interval. By analyzing these isometric intervals, one can arrive at some determination of ethnic style[65].

The study of the evolution of systems of proportions and canons in African statuary is a new way in the research of African art history.

Bernard Fagg already noticed that the proportions of the human body of Nok figures was

fairly constant. Whereas in nature, the objective proportions of the head to the whole body are in the ratio of about one to seven, in the Nok terracottas, it is between one to three and one to four.

William Fagg, brother of Bernard and the foremost art historian of sub-Saharan Africa, has called this canon "the African proportion"[66]. This canon where the height of the head is used as the standard yardstick repeated three or four times for the total height of any human representation was thus firmly established more than 2000 years ago by Nok artists. This set of proportions first invented by Nok artists should then be called the Nok canon.

Ife and Benin artists continued to use this set of proportions later for the bronze and clay statuary. It is also used by numerous tribal styles carved in wood.

One should note however that in Nigeria, other canons were available and used. Among the Ibo for instance, their life-size wooden statuary use an organic canon with a one to seven ratio whereas among the Mumuye, one finds a similar situation as the one I analyzed for Fang statuary in Gabon: a multiplication of different sets of proportions in their reliquary guardian figures[67].

The Nok canon appears to be as powerful as the one invented by Polykleitos since its simplicity of use made it the most widely-used canon in all of African sculpture, starting more than three thousand years ago with Nok art and spreading in many sculptural styles of West and Central Africa.

Is Nok art one of the proto-Bantu artistic languages?

All these new discoveries have enriched considerably our knowledge of Nok art. They confirm the hypothesis that the cradle of a theory of artistic proportions in African art based on a canon where the height of the head is used as the standard yardstick repeated three or four times for the total height of a human representation was thus firmly established more than two thousand years ago by Nok artists. Ife and Benin artists continued to use this set of proportions later for bronze and clay statuary. It is not the only canon

used later by numerous tribal styles but certainly the most popular.

Art being a type of language, let us name this Nok canon an African proto-style by analogy to the proto-Bantu language, that is to say the now-lost ancestral Bantu language which evolved into the six hundred Bantu languages spoken today in Central and Southern Africa by more than one hundred and forty million people.

According to recent studies in comparative linguistics, one of the Bantu cradle areas from which such a large number of languages dispersed is situated either at the borders of Cameroon and Nigeria, around the Bamenda highlands, or more towards the West, at the confluence of the Benue and Niger rivers, very close to the area where Nok art has been discovered.[68]

Already in 1955, during conversations with Bernard Fagg, Joseph Greenberg, one of the most respected linguists on Bantu languages, suggested the existence of a proto-Bantu language in a cradle area including the Jos plateau.[69]

Thanks to new disciplines in linguistic studies such as lexicostatistics and glottochronology, scholars agree to date the beginning of the dispersal of Bantu languages at the earliest around 3000 BC et at the latest around 500 BC.

This dispersal of languages lasted more than two thousand years and took place in successive waves, following river banks, elephant and other big game tracks in the forest and coastal regions. It happened in nine successive spreads and there was never a single large-scale invasion of large hordes of Bantu speakers but population movements or language shifts of groups which mastered either pottery firing techniques, the cultivation of root-crops (yam), or the organizational skills of sedentarized villages populated by up to five hundred inhabitants.

It seems obvious that a local population will only adopt a new language if it appears to be more prestigious, useful or possess economic advantages. In the past, scholars have connected this spread of new Bantu languages with the arrival of a new technology of iron-working.[70] Recent research has shown that proto-Bantu neither smelted nor used metal.[71]

We would like to propose that this prestige could have been partially caused by the artistic skills of some proto-Bantu speakers such as the

Nok people. Anonymous Nok artists had invented a new canon for the representation of the human figure, a set of rules and proportions some time after the appearance of proto-Bantu languages in a region not far from this cradle area. This artistic canon, a purely intellectual notion, allowed the resolution of the essential problem of transmittal of a common artistic language from one population to another.

One should not forget however that other artistically inclined groups which are now just being researched and which were living around that time in Nigeria could have also played an important role in the birth of art in that area. The Ejagham people from Cross River State (south of the Nok area) began carving elaborate stone monoliths very early. According to the results of recent excavations by Ekpo Eyo, as early as 200 AD members of the Bakor clan of the Ejagham were carving elaborate stone monuments called atal which were portraits of important clan leaders and other cultural heroes.[72]

This is not unique in the history of art. One can look at the immense artistic legacy of Alexander the Great whose international Hellenistic style, helped of course by the intellectual unity and strength of the koine, has influenced the art of all the great kingdoms of the Mediterranean basin, the Middle East and Central Asia all the way to Kazakhstan, Afganistan and China.[73]

An argument supporting this hypothesis is the appearance for the first time in Nok statuary of certain specific sacred gestures which have surfaced subsequently in other Bantu-speaking populations from Central Africa.

Let us take a very specific gesture: a human female figure, standing, arms folded, hands resting on breasts. As illustrated in the map opposite, this gesture invented by Nok people is found represented on statues from tribes situated along the dispersal routes of Bantu languages, whether it is on the Western Bantu such as Fang, Tshogo, Kongo and Suku statues or among eastern Bantu people and statues from the Luba and Bembe.

Of course, one will immediately object that there exists an enormous spatial and chronological gap between a Nok statue found in eastern Nigeria and dated to 500 BC and a Kongo or Luba statue found many thousands of miles away and dated to the nineteenth century. This is true but one should never forget the following: the relative age of a Kongo or Luba statue should be related to the absolute age of the date of creation of the Luba or Kongo prime object. Each statue is just one more link in a chain of statues whose length (thus age) can vary considerably. The Kongo kingdom seems to have been founded around 700-800 AD whereas the roots of the Luba empire go back to around 500 AD.[74] The chronological gap between Nok art and other sculptures by Bantu speakers seems to be narrower in this light and a relationship from one to the other seems more plausible.

Nok terracottas can be considered as the archetypes of artistic creativity in Black Africa. These superb sculptures which were created over more than one thousand years remain the oldest surviving witnesses of the incredibly strong creative urge of the many populations of sub-Saharan Africa that speak the languages of the Niger-Congo family.

Further research could focus on the role of Nok art in the art history of Nigeria, more specifically on the stylistic relationships between Nok sculpture and later Ife and Benin art. Despite certain similarities, a direct filiation between Nok and Ife seems unlikely. Let us hope that further research will help to better understand the art history of Nigeria and its possible influences on other styles of sub-Saharan Africa.

BERNARD DE GRUNNE

Dispersion map of the Bantu languages in relation
to the distribution of certain sacred gestures from Nok to Luba

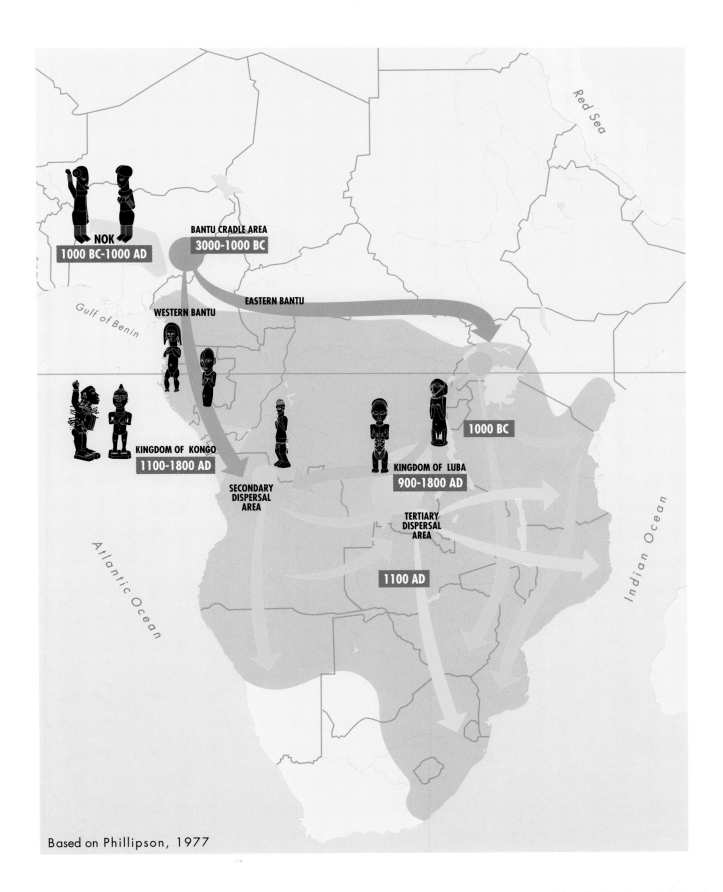

NOK
1000 BC-1000 AD

BANTU CRADLE AREA
3000-1000 BC

EASTERN BANTU

WESTERN BANTU

Gulf of Benin

0°

KINGDOM OF KONGO
1100-1800 AD

SECONDARY
DISPERSAL
AREA

KINGDOM OF LUBA
900-1800 AD

1000 BC

TERTIARY
DISPERSAL
AREA

1100 AD

Atlantic Ocean

Indian Ocean

Red Sea

Based on Phillipson, 1977

1. The Ham are also called Jaba by the Hausa,
cf. Bernard Fagg, *Nok Terracottas*, Lagos, 1977,
p. 11 and 14.
2. I will always refer to the numbers in Fagg's *catalogue raisonné* of 1977 in order to identify each published Nok piece. This head is n° 3 in Fagg,
op. cit., 1977.
3. B. Fagg, "A Preliminary Note on a Series of Pottery Figurines from Northern Nigeria", in *Africa*, XV (1), 1945,
p. 21-22.
4. B. Fagg, *op. cit.*, 1977, n° 6 and 27-29
5. B. Fagg, "The Nok Culture in Prehistory",
in *Journal of the Historical Society of Nigeria*, 4, 1959,
p. 288-93; B.Fagg, *op. cit.*, 1977, n° 27 to 29 and
T. Shaw, "The Nok Sculpture of Nigeria", in *Scientific American*, n° 224, 3, February 1981, p. 119.
6. B. Fagg, *Nok Terracottas*, Lagos, Ethnographica, 1977,
n° 9
7. The chart published by the Nigerian scholar Yashim Isa Bitiyong is revealing: 42% of the pieces discovered come from the site of Nok and 30% from Jemaa. Those two sites provide 72% of all Nok objects. *Cf.* Yashim Isa Bitiyong, "Culture Nok, Nigeria",
in *Vallées du Niger*, Paris, Réunion des musées nationaux, 1993, p. 395.
8. B. Fagg, "The Nok Culture", in *West African Review*, December 1956, pp. 1083-87.
9. B. Fagg, *op. cit.*, 1977, n° 92
10. B. Fagg, "The Nok Culture: Excavations at Taruga",
in *West African Archeological Newsletter*, 1968,
n° 10, p. 27-30 and B. Fagg, "Recent Work in West Africa: New Light on Nok Culture", in *World Archeology*, 1969,
n°1, p. 41-49.
11. Fagg, *op. cit.*, 1977, n° 22 and 26
12. Fagg, *op. cit.*, 1977, n° 23
13. *Idem*, n° 92 and 148
14. A. J. Priddy, "RS/62/32: An Early Iron Age Site near Yelwa, Sokoto Province: Preliminary Report", in *West African Archeological Newsletter*, n° 12, 1970,
p. 55-68
15. F. Willett, "A Missing Millennium? From Nok to Ife and Beyond", in E. Bassani, ed., *Art in Africa*, Modena, 1984,
p. 92-93.
16. T. Shaw, *Nigeria. Its Archeology and Early History*,
London, 1978, fig. 51 and 52.
17. A. Fagg, "A Preliminary Report on an Occupation Site in the Nok Valley, Nigeria: Samun Dukiya, AF/70/1", in *West African Journal of Archeology*, 1972, n° 2, p. 75-79.
18. J. F. Jemkour, *Aspects of the Nok Culture*, Ahmadu Bello University Press, Zaria, 1992, p. 41-49.
19. E. Coulibaly and V. Chieze, "Histoire du fer",
in *Vallées du Niger*, Paris, Réunion des musées nationaux, Paris, 1993, p. 337
20. F. Paris, Y. Person, G. Quéchon et J. F. Saliège,
"Les débuts de la métallurgie au Niger septentrional
(Aïr, Azawagh, Ighazer, Termit)", in *Journal de la Société des Africanistes*, 1992, n° 62, 2, p. 55-68

21. C. Abedayo Folorunso, "Le corridor Benue-Tchad: perspectives archéologiques", in *Vallées du Niger*, Paris, Réunion des musées nationaux, 1993, p. 118
22. B. Fagg, *Nok Terracottas*, Lagos, Ethnographica, 1977,
p. 20.
23. *Cf.* charts in Y. Bitiyong, "Culture Nok, Nigeria",
in *Vallées du Niger*, Paris, Réunion des musées nationaux, 1993, chart 3 and 4, p. 396-397 and the recalibrated dates done by J. F. Saliège and published in C. Boullier, *Les sculptures en terre cuite de style Nok: approche pluridisciplinaire*, Mémoire DEA, Paris, Université de Paris I-Panthéon, 1995-96,
p. 21-23
24. These dates were produced by the British Museum
n° BM 535 & BM 939, in R. Burleigh et al., "British Museum Natural Radiocarbon Measurements IX", in *Radiocarbon*, vol. 19, 2, 1977, p. 155.
25. Y. Bitiyong, *op.cit.*, chart 3, p. 396
26. B. Fagg and S. J. Fleming, "Thermoluminescence dating of a Terracotta of the Nok Culture, Nigeria",
in *Archeometry*, 12 (1), 1977, p. 55
27. J. F. Jemkour, *Aspects of Nok Culture*, Ahmadu Bello University Press, Zaria, 1992, p. 69
28. B. Fagg, *Nok Terracottas*, Lagos, Ethnographica, 1977,
n° 47
29. A recent master's thesis from 1995 by Claire Boullier at the University of Paris I under the supervision of professor Yves Person has already extended the known corpus to approximately three hundred pieces. See Boullier, *op. cit.*, 1995, p. 30.
30.J. F. Jemkour, *Aspects of Nok Culture*, Ahmadu Bello University Press, Zaria, 1992, plates 8-9
31. B. Fagg, "The Nok Culture in Prehistory"
in *Journal of the Historical Society of Nigeria*,
vol. 1(4), p. 290
32. B. Fagg, *Nok Terracottas*, Lagos, Ethnographica, 1977,
p. 29
33. C. K. Meek, *Tribal Studies in Northern Nigeria*,
New York, The Humanities Press, 1950, vol. 1, plate 51.
34. *Idem*, plate 35
35. C. K. Meek, *The Northern Tribes of Nigeria*, Oxford University Press, 1925, p. 41
36. Pitt-Rivers Museum n° 1920 58.3&4, 1921 28.5,
cf. Peter J. Ucko, "Penis sheaths: A Comparative Study", in *Proceedings of the Royal Anthropological Institute of Great Britain and Ireland for 1969*, plate 1.
37. It was recently published in the exhibition catalogue *Africa. The Art of a Continent*, T. Phillips,ed., Prestel Verlag, Munich, 1995, fig. 1.22, p. 69
38. W. Fagg, *Merveilles de l'art nigérien*, Paris, Chêne, 1963,
p. 12
39. Y. Bitiyong, "Culture Nok", in *Vallées du Niger*, Paris, Réunion des musées nationaux, 1993, p. 395
40. See Y. Bitiyong, *op.cit.*, p. 398-407; F. Willett had one of his students prepare a map showing the distribution of styles by site, *cf.* F. Willett, "A Missing Millenium? From Nok to Ife and Beyond",

in E. Bassani, ed., *Arte in Africa*, Ed. Panini, Modena, 1984, p. 87

41. F. Chamoux, *La civilisation grecque*, Arthaud, Paris, 1963, p. 404-5.

42. B. Fagg, *Nok Terracottas*, Lagos, Ethnographica, 1977, n° 17

43. C. Avery, "modello", in J. Turner, ed., *The Dictionary of Art*, Grove, London, 1996, vol. 21, p. 767-771

44. R. Lehuard in *Arts d'Afrique Noire* , n°88, Winter 1993, p.59

45. F. Willet, "L'archéologie de l'art nigérian", in H. Martin, C. Féau and H. Joubert, *Arts du Nigéria*, Réunion des musées nationaux, Paris, 1997, p. 26

46. E. Eyo, *Two Thousand Years of Nigerian Art*, Lagos, 1977, p. 194

47. B. Fagg, *Nok Terracottas*, Lagos, Ethnographica, 1977, n° 21

48. T. Shaw, *Nigeria. Its Archeology and Early History*, London, Thames and Hudson, 1978, p. 97

49. R. F. Thompson, "The Sign of the Divine King: Yoruba Bead embroidered Crowns with Veil and Bird Decorations", in D. Fraser and H. Cole, *African Art and Leadership*, Madison, University of Wisconsin Press, 1972, p. 246

50. *Idem*, p. 228.

51. F. Kent Reilly III, "The Shaman in Transformation Pose: A Study of the Theme of Rulership in Olmec Art", in *Record of the Art Museum of Princeton University*, vol. 48, n° 2 1989

52. M. Eliade and I. Couliano, *Dictionnaire des religions*, Plon, Paris, 1990, p. 100

53. A. Wardwell, *Tangible Visions. Northwest Coast Indian Shamanism and its Art*, New York, The Monacelli Press, 1996

54. P. Furst, "Shamanism, Transformation and Olmec Art", in *The Olmec World. Ritual and Rulership*, The Art Museum, Princeton Museum, 1995, p. 69-81

55. G. Rouget, *La musique et la transe*, Paris, Gallimard, 1980, p. 52 et L. De Heusch, "Possession et chamanisme", in *Pourquoi l'épouser*, Paris, Gallimard, 1971, p. 261

56. T. N. Huffman, "The Soapstone Birds from Great Zimbabwe", in *African Arts*, 18(3), 1985, p. 68-73.

57. Formerly in the Norman Colville and Rasmussen collections, see M. Allemand, *L'art de l'Afrique noire et l'époque nègre de quelques artistes contemporains*, Saint Etienne, 1956, fig. 5.

58. As painted by the Stamos Painter, *cf.* J. Charbonneaux, *La Grèce classique*, NRF Gallimard, Paris, 1969, fig. 264

59. J. Nevadomsky, "Kemwin-Kemwin: The Apothecary Shop in Benin City", in *African Arts*, November 1988, 22(1), p. 74.

60. P. Ben-Amos, "The Powers of Kings: Symbolism of a Benin Ceremonial Stool", in P. Ben-Amos and A. Rubin, *The Art of Power. The Power of Art*, UCLA, 1983, fig. 45.

61. B. de Grunne, *Ancient Terracottas from West Africa*, Louvain-La-Neuve, 1980, fig. I.32, D. McCall, "The Hornbill and Analogous Forms in West African Scultpure," in McCall and E. Bay, *African Images. Essays in African Iconology*, Boston University, 1975, p. 268-324 and A. Duchateau, *Benin. Trésor royal*, Paris, Musée Dapper, 1990, p. 77.

62. K. F. Schaedler, *Earth and Ore*, Panterra Verlag, München, 1997, fig. 375.

63. A. H. Borbein, "Polykleitos", in O. Palagia and J. J. Pollitt, *Personal Style in Greek Sculpture*, Yale Classical Studies, Cambridge, 1997, p. 87

64. E. Panofsky, "L'histoire de la théorie des proportions humaines, conçue comme un miroir de l'histoire des styles", in E. Panofsky, *L'oeuvre d'art et ses significations*, Paris, 1969, p. 55-100.

65. A. Leroi-Gourhan, "Observations technologiques sur le rythme statuaire", in F. Pouillon, ed., *Echange et Communication,* Mouton, La Haye, 1970, p. 667

66. W. Fagg, *Merveilles de l'art Nigérian*, Paris, Chêne, 1963, p. 13

67. B. de Grunne, "La statuaire Fang. Une forme d'art classique", in *Tribal Arts*, n° 2, June 1994, p. 49-50

68. K. Williamson, "Le pedigree des nations: linguistique historique au Nigeria", in *Vallées du Niger*, Paris, Réunion des musées nationaux, 1993, p. 267-270

69. B. Fagg, "A Life-Size Terracotta Head from Nok", in *Man*, 1956, p. 89

70. D.W. Phillipson, "The Spread of Bantu Language", in *Scientific American*, April 1977, vol. 236 (4), p. 106-114.

71. J. Vansina, "New Linguistic Evidence and the Bantu Expansion", in *Journal of African History*, 36, 1995, p. 189

72. I want to thank Professor Robert F. Thomspon for this informatiom. See E. Eyo, "Alok and Emangabe stone monoliths: Ikom, Corss River State of Nigeria", in E. Bassani, ed., *Arte in Africa*, ed. Panini, Modena, 1983, p. 101-104 and E. Eyo, "Monoliths Balor (Atal) Ejagham de l'État de la Cross River", in H. Martin, E. Féau and H. Joubert, *Arts du Nigéria*, Réunion des musées nationaux, Paris, 1997, p. 169-170

73. K. Papaioaunnou, *L'art grec*, Mazenod, Paris, 1975, p. 163-65

74. N. Batulukisi, "Pré- et Proto-histoire de la région Kongophone", in M. Feliw, *Art & Kongo*, Brussels, 1995, p. 42 and S. Terry Chils and P. de Maret, "Reconstructing Luba Past's", in M. Nooter Roberts and A. F. Roberts, *Memory Luba Art and the Making of History*, New York, The Museum of African Art, 1996, p. 56

CATALOG

Opposite page:
1. LARGE MALE STATUE
ON BENDED KNEE
Height: 25 inches
Date: TL 51197
(AD 150 ± 200 years)

The movement in this beautiful statue has a natural elegance. The missing right arm was raised and the hand was probably placed on the head.

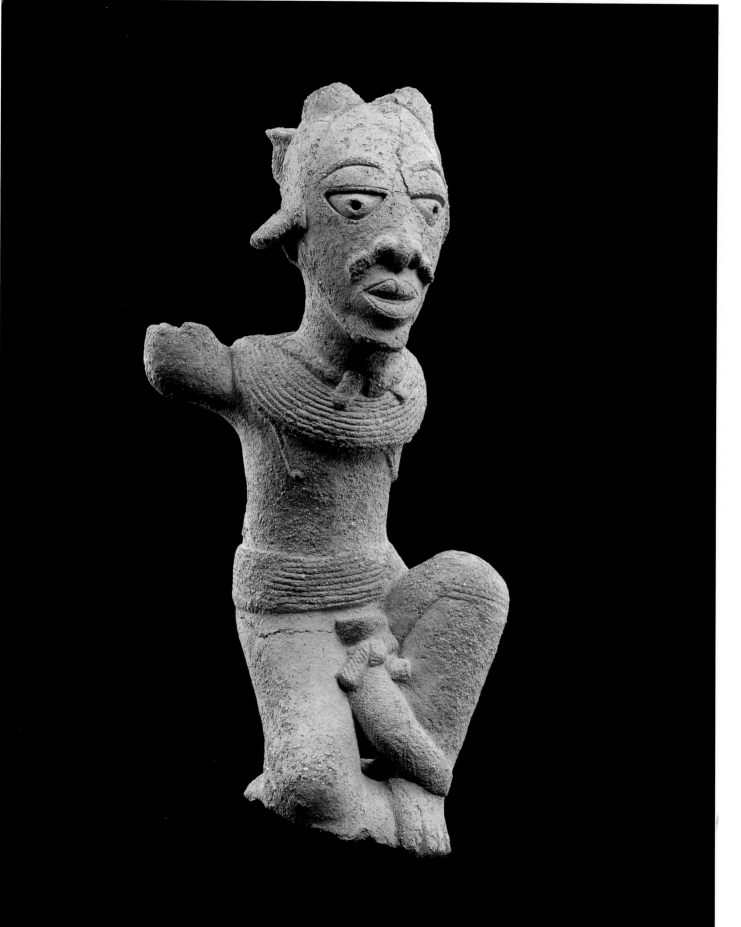

2. LARGE BUST
WITH RAISED ARM
Height: 19 1/2 inches
Date: TL 55081
(400 BC ± 220 years)
C14: ETH 14893
(650 BC ± 150 years)

This magnificent bust is a striking illustration of the diversity and complexity of Nok headdresses. This is most probably a high-ranking figure, covered with necklaces and bracelets. His beard is finely braided and his face carries the haughty expression of a person assured of his own power. It was possible to cross-date this object using thermoluminescence and carbon dating, as fragments of burned wood were recovered when the statue was unearthed.

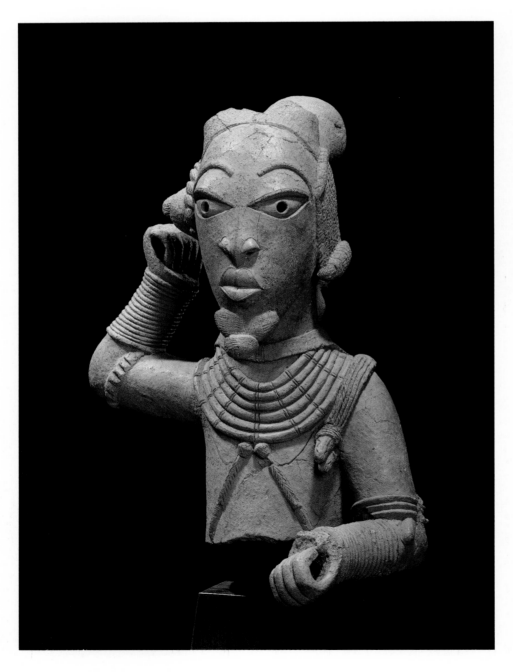

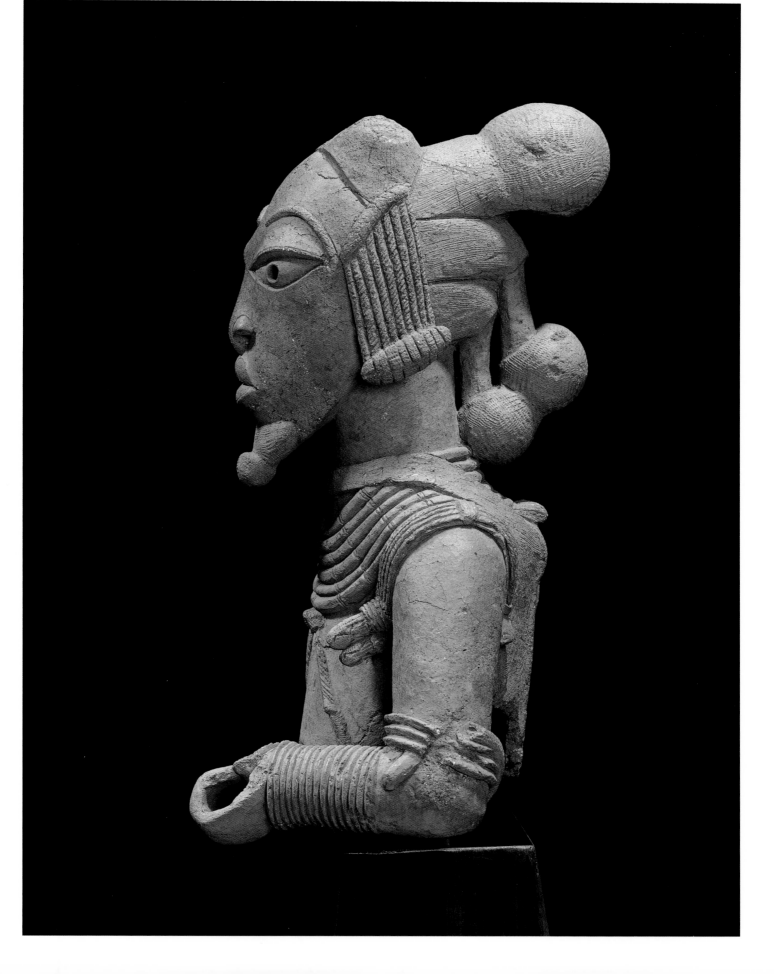

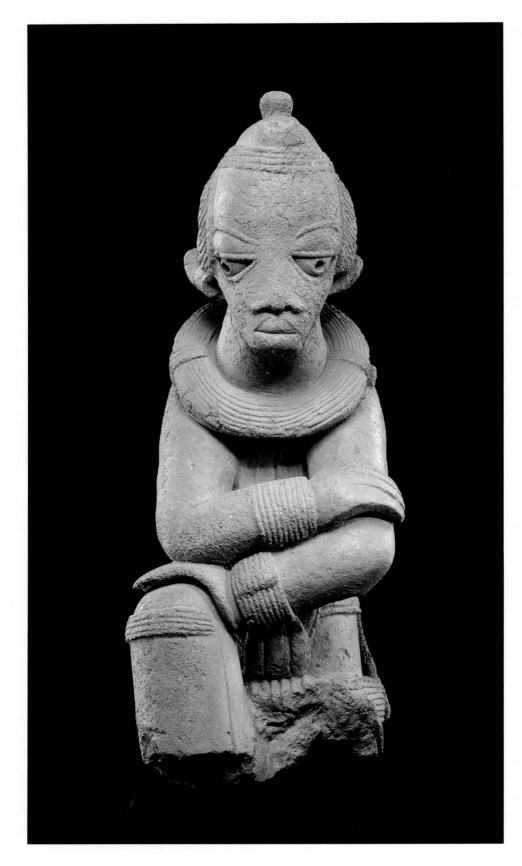

3. STATUE ON BENDED KNEE
Height: 22 1/4 inches
Date: TL Lutt/1995/136
(450 BC ± 240 years)

The left knee of this statue is missing, but the figure is clearly on bended knee in a classical position, with one knee pulled up to the torso and the other touching the ground. The arms resting on the knees confers a degree of serenity on this figure, which seems to be deep in thought.

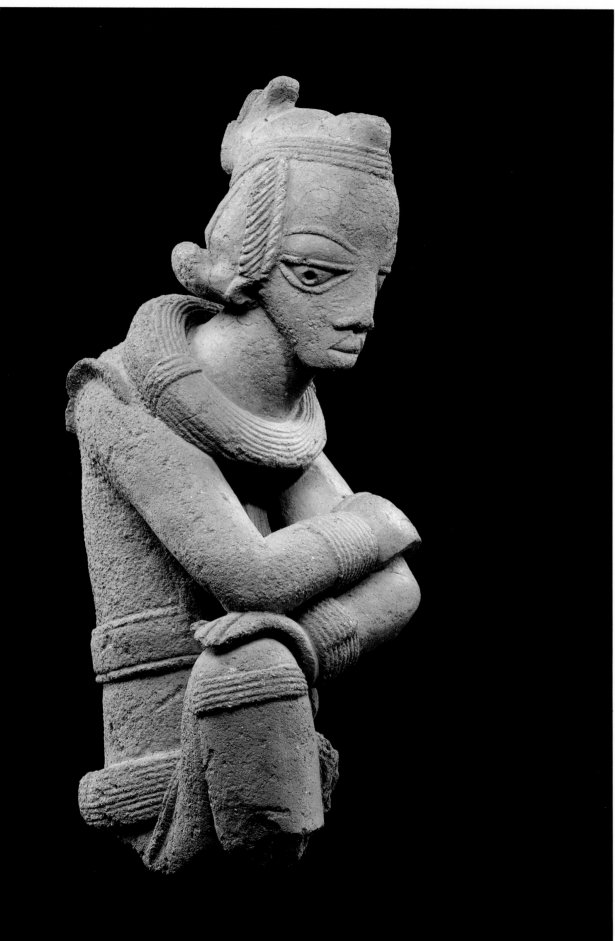

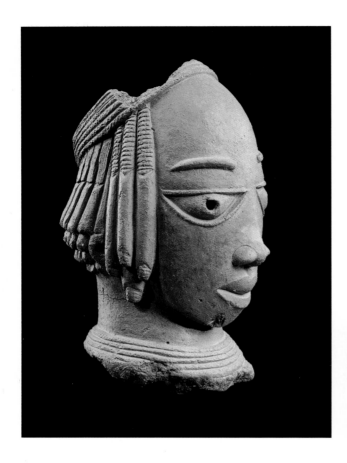

4. HEAD
Height: 11 inches

This is a female torso: her breasts are clearly sculpted, the characteristic genital covering is made of a braided mass in the front and a piece of folded fabric behind. The strict composition of this sculpture and her perfectly straight back are reminiscent of Khmer torsos. We have included an illustration of another head, in which the modeling of the face, the headdress and the slip seem to indicate that the two objects come from the same site.

Opposite page and right
5. TORSO
OF A FEMALE FIGURE
Height: 24 1/8 inches
Date: TL 9206
(AD 100 ± 200 years)

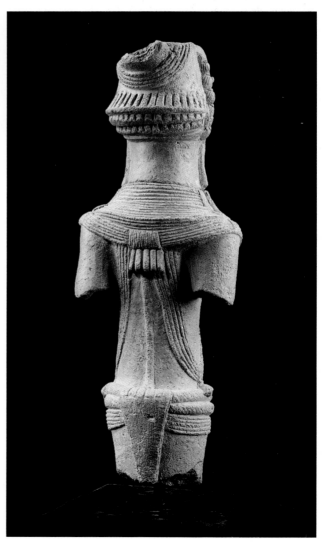

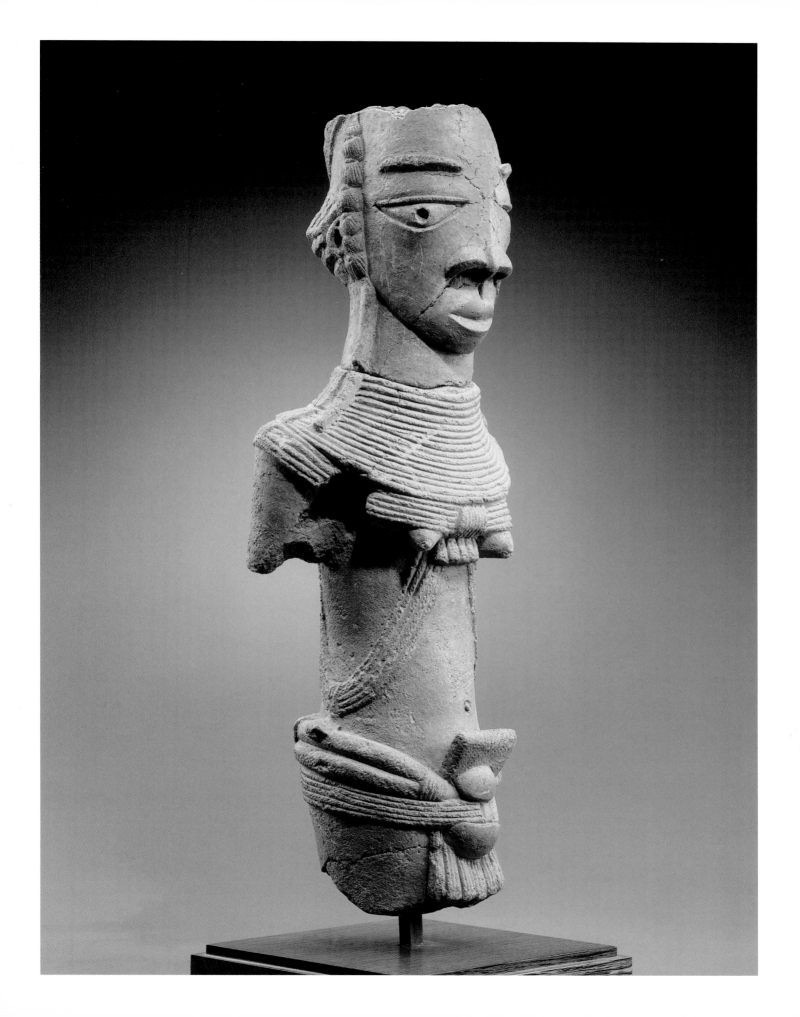

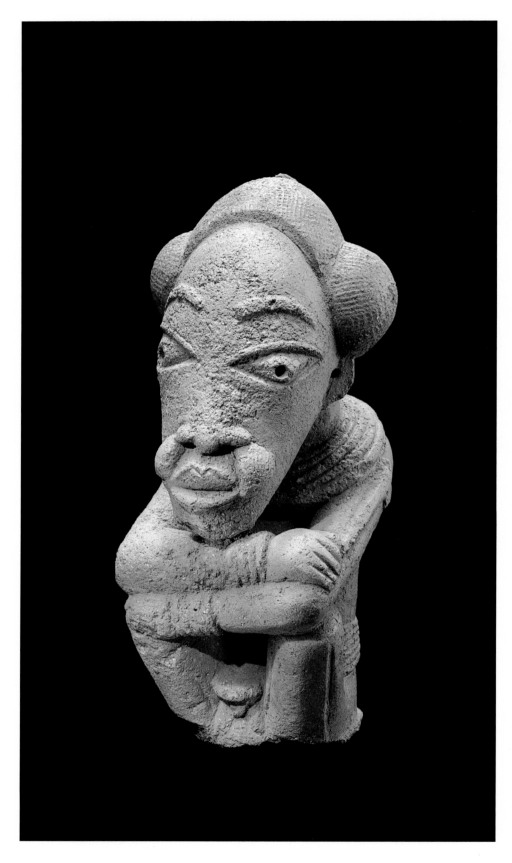

Left:
6. KATSINA ALA STYLE
SEATED MALE
STATUETTE
Height: 10 3/4 inches
Date: TL 2205
(150 BC ± 200 years)

Opposite page:
7. KATSINA ALA STYLE
SEATED MALE FIGURE
Height: 23 inches
Date: TL 606005
(400 BC ± 250 years)

For our purposes, we have temporarily grouped all the statues and heads with very elongated faces into a single style, the Katsina style, so-named because the first of these highly original heads was discovered at Katsina. Fragments of several seated statues were also discovered at this site. In the following texts, we therefore have grouped together all the heads and all the small and large statues to which this style can be attributed.

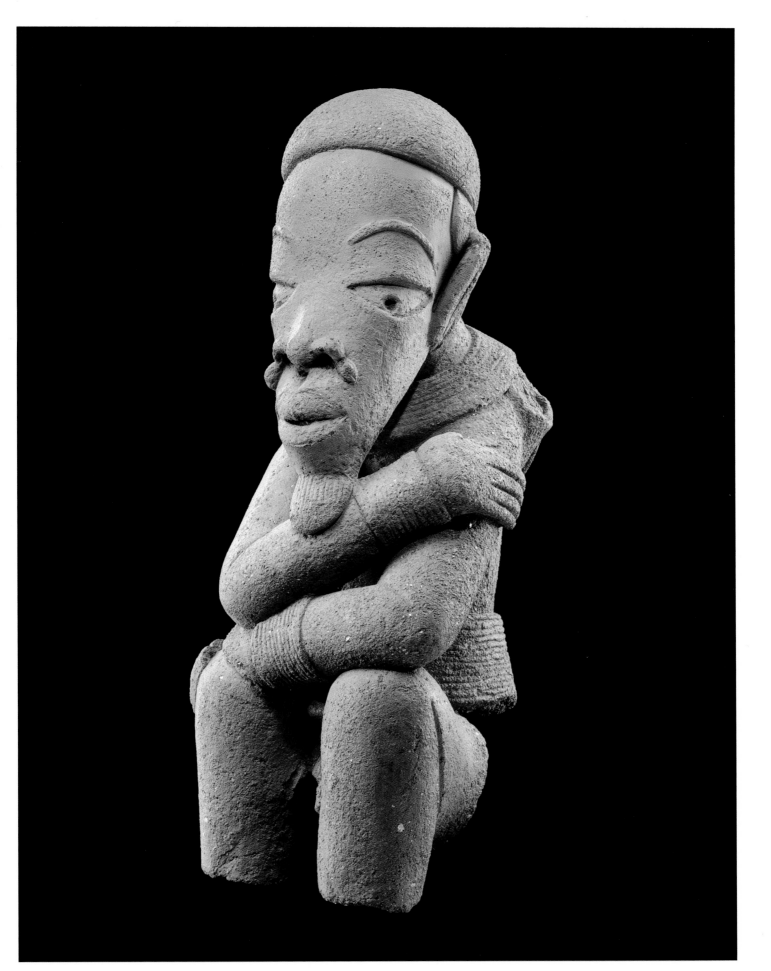

Below:
8. KATSINA ALA STYLE
HEAD
Height: 9 3/8 inches
Date: TL 51195
(50 BC ± 200 years)

Opposite page:
9. KATSINA ALA STYLE
HEAD
Height: 10 1/2 inches
Date: TL 9114
(300 BC ± 250 years)

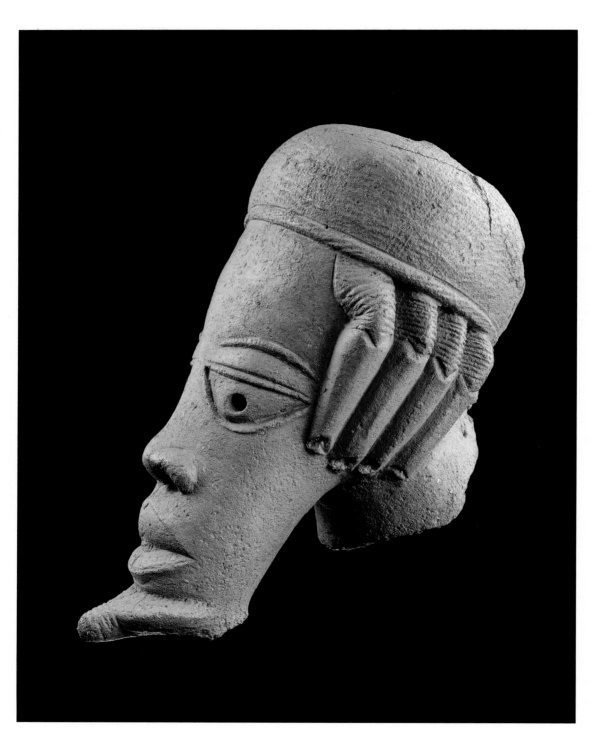

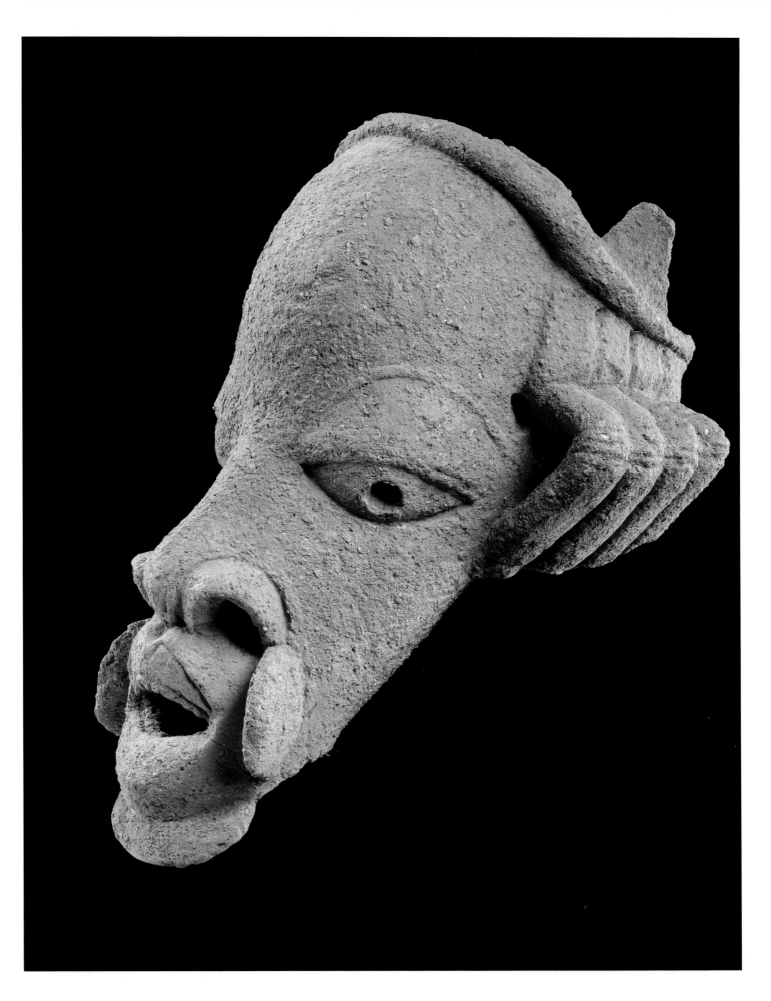

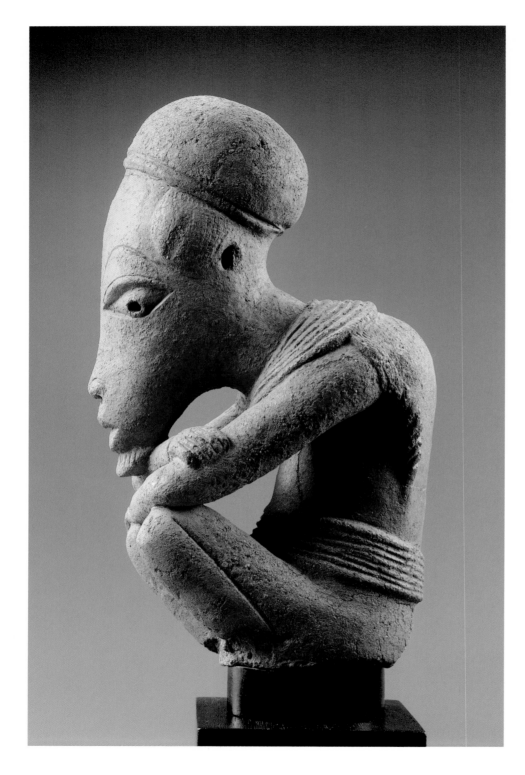

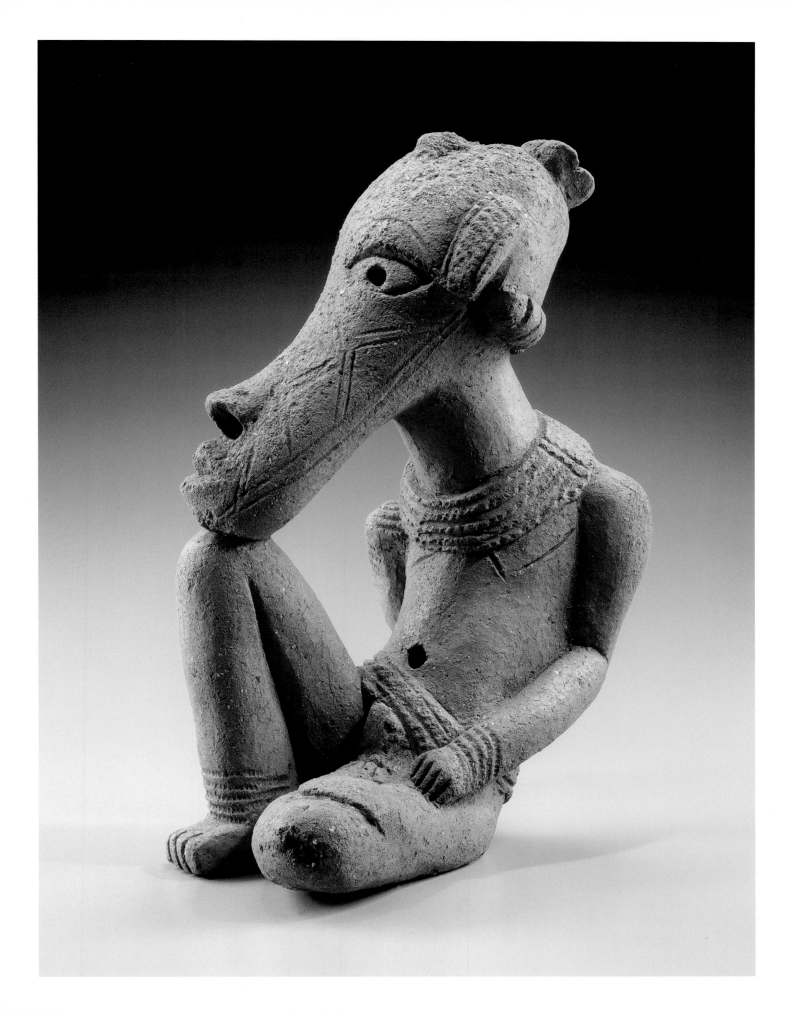

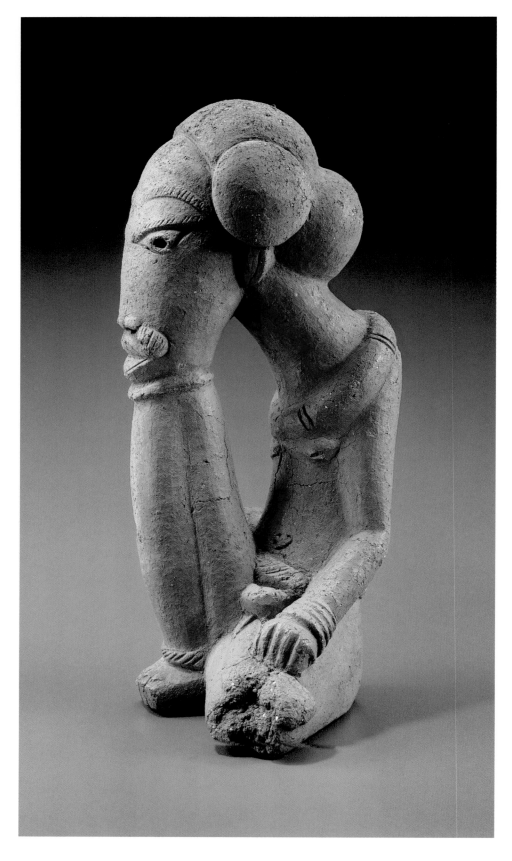

Left:
12. KATSINA ALA STYLE
SEATED MALE
STATUETTE
Height: 8 3/4 inches
Date: TL 804 224
(330 BC ±300 years)

Opposite page:
13. KATSINA ALA STYLE
SEATED MALE
STATUETTE
Height: 12 inches
Date: TL 709013
(150 BC ± 200 years)

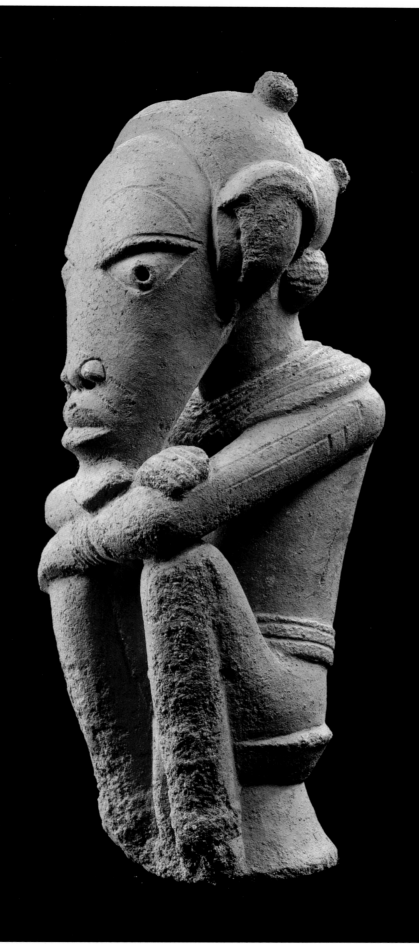

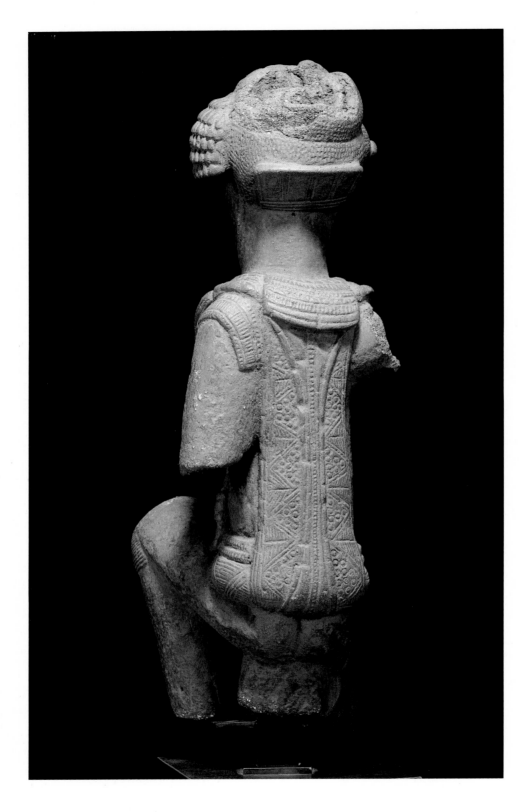

14. LARGE MALE
STATUE ON BENDED
KNEE
Height: 21 1/4 inches
Date: TL 55023
(150 BC ± 200 years)

This statue is
unusual—it is one
of the rare to depict
details of clothing, in
this case an elegant
cape-like covering worn
over the back. The
beautiful, smooth slip
has survived, which
gives a better idea of the
original condition of
these objects during the
Nok era. The simplicity
of the sculpted details
of the face creates a
well-balanced contrast
to the complexity of
the headdress, while
the exaggeration of
the bent left knee adds
to the strength of the
sculpture.

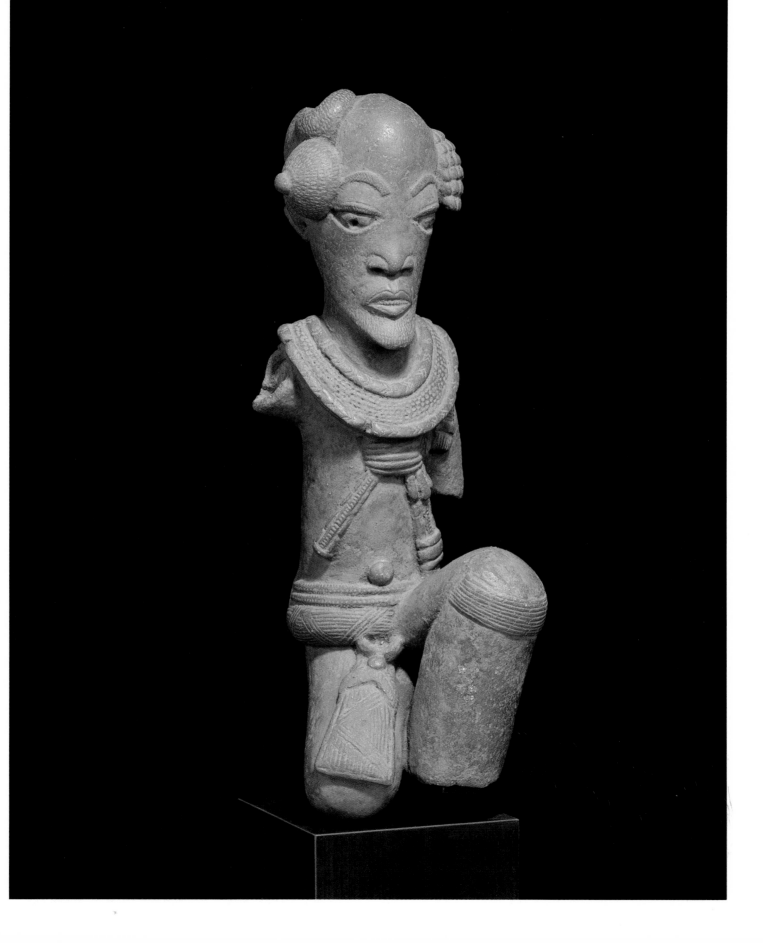

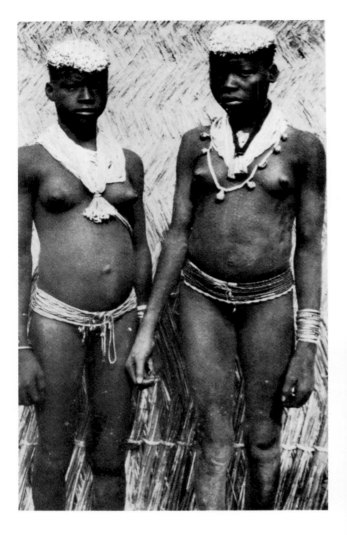

These pillar-statues, which resemble the Hermaic statues of ancient Greece, were placed on altars, not on rooftops as with the Dakakari ethnic group. The name of the style given to this type of sculpture—Kuchamfa—comes from a magnificent fragment of a pillar-statue now in the collection of the Jos Museum. It was discovered at the Kuchamfa site.

Opposite page:
16. LARGE KUCHAMFA-STYLE FEMALE PILLAR-STATUE
Height: 35 1/2 inches
Date: TL Lutt/1994(265)
(150 BC ± 220 years)

Above:
TWO YOUNG YENDANG GIRLS, Nigeria.
Photograph published in *Tribal Studies in Northern Nigeria*, by Charles K. Meek, New York, 1950, p. 483.

Right:
15. SMALL KUCHAMFA-STYLE MALE PILLAR-STATUE
Height: 13 7/8 inches

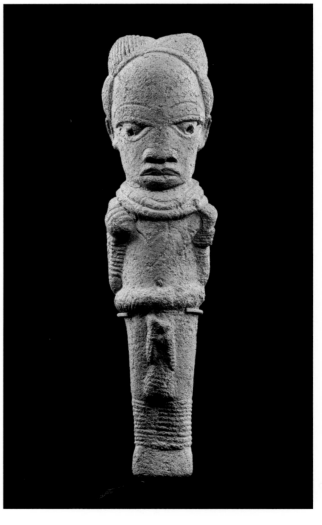

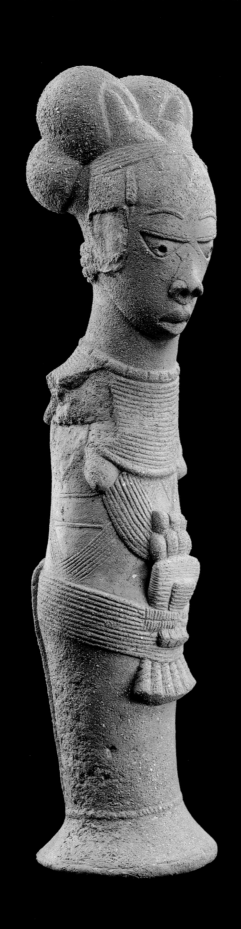

Right:
TWO YOUNG YENDANG
GIRLS SEEN FROM THE
BACK. Photograph
published in *Tribal
Studies in Northern
Nigeria*, by
Charles K. Meek,
New York, 1950, p. 483.

*Opposite page
and below:*
17. LARGE KUCHAMFA-
STYLE FEMALE PILLAR-
STATUE
Height: 26 3/4 inches
Date: TL 712206
(50 BC ± 200 years)

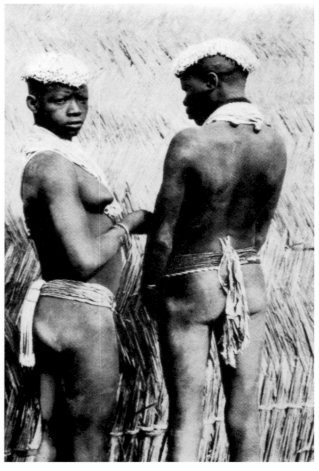

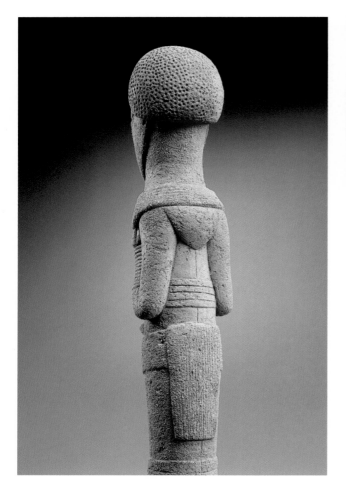

The figure of this woman, whose genital covering and breasts are clearly indicated, radiates a subdued elegance. Her position, with arms folded and hands placed on the sides of her breasts, is a very strong pose, one that was widely adopted throughout sub-Saharan Africa. It can be seen in the statues of many Bantu groups, and in Fang, Tsogho, Kongo and Suku statues, and even in works by the Luba and Boyo tribes. Meek's photograph illustrates two young girls wearing clothing similar to those of this statue.

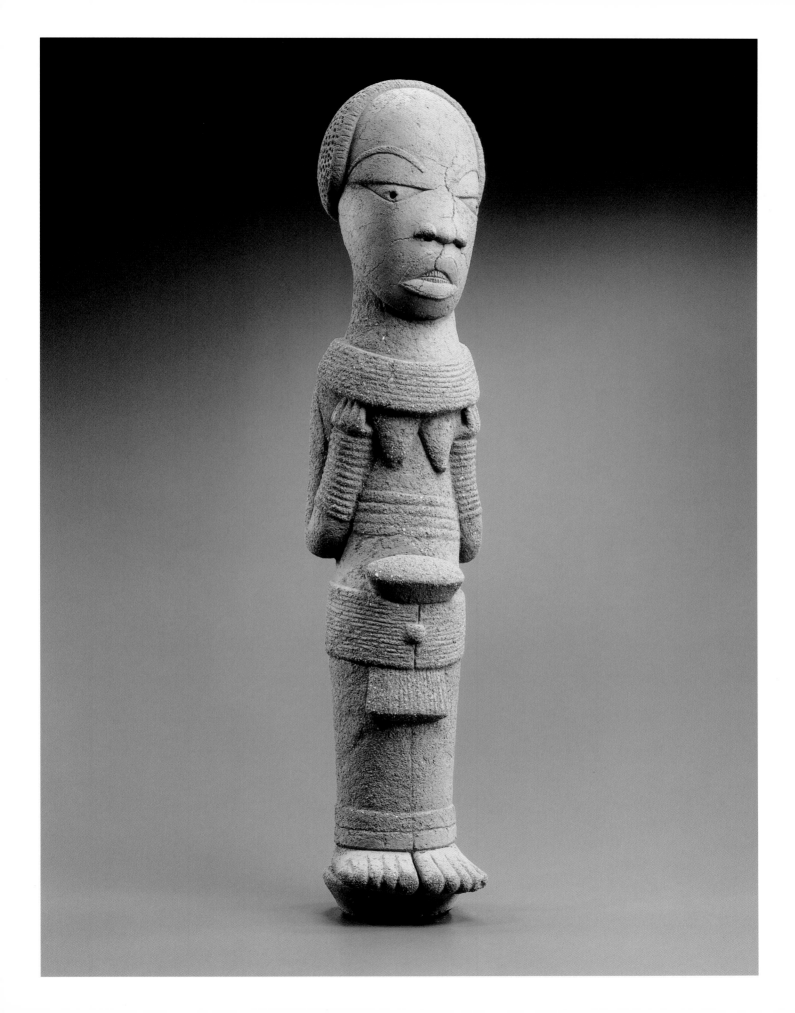

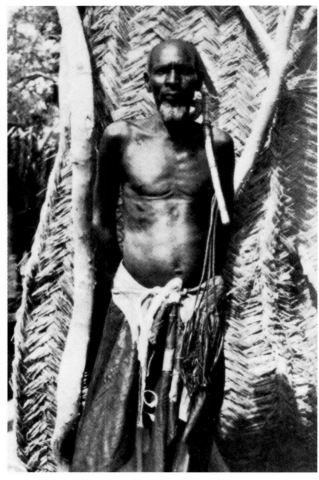

Above:
PRIEST WITH SCEPTER,
FROM THE NZEANZO
CULT, THE BACHAMA,
Nigeria. Photograph
published
in *Tribal Studies in
Northern Nigeria*,
by Charles K. Meek,
New York, 1950,
p. 28 and 34.

This man is grasping in his right hand a type of curved scepter with a hooked end, seen in a certain number of Nok statues. The scepter resembles the insignia for spiritual power carried by the priests and ancients who have been initiated into the cult of Nzeanzo, the supreme god and civilizing hero of the Bachama, who lived near the town of Numan on the Benue, ninety miles east of Jos.

Opposite page:
18. FEMALE BUST
Height: 17 7/8 inches
Date: TL 603016
(250 BC ± 220 years)

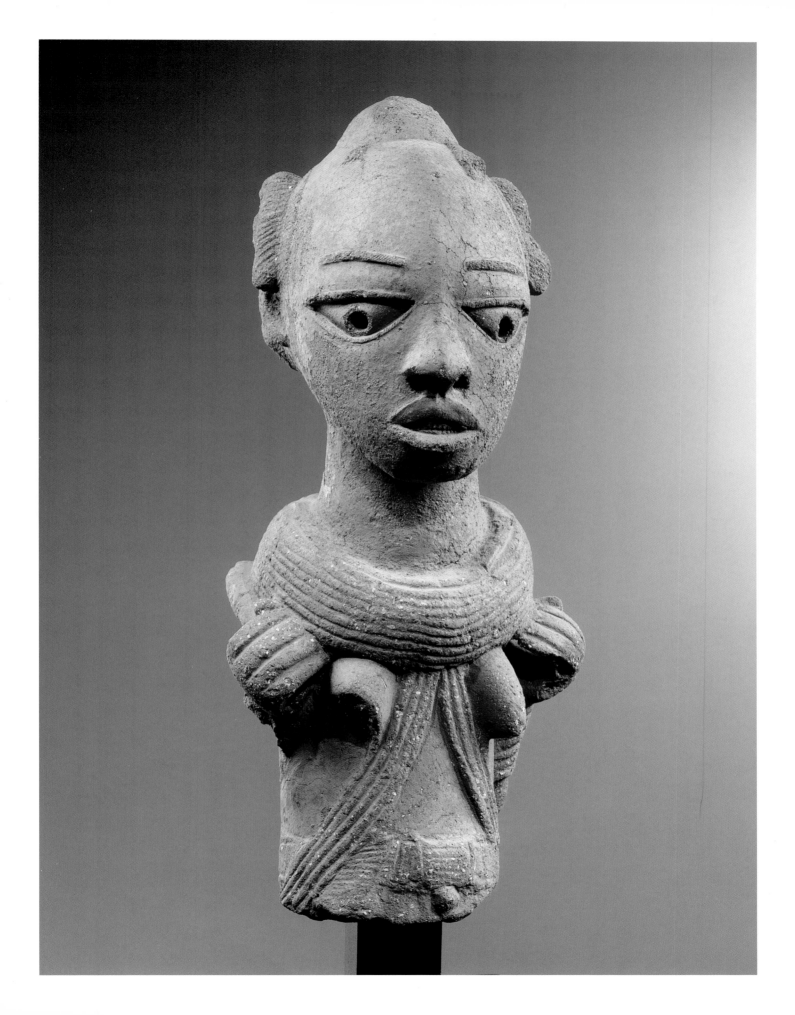

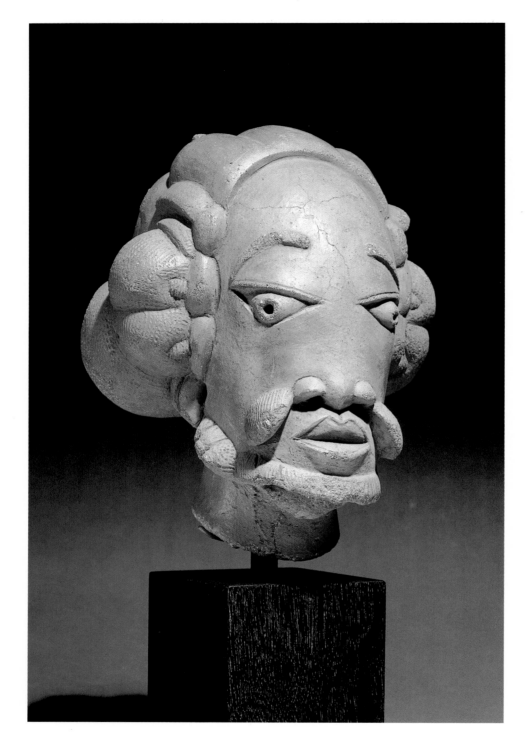

Left:
19. MALE HEAD
Height: 9 3/4 inches
Date: TL 706211
(50 BC ±200 years)

Opposite page:
20. FEMALE BUST
Height: 17 inches
Date: TL 55031
(250 BC ± 200 years)

The Nok headdresses are infinitely diverse. Here, the hair is rendered as an independent sculpture, with amazingly large chignons along the side. Note that the headdresses are not necessarily more elaborate on the female statues: one of these statues represents a woman, the other a man.

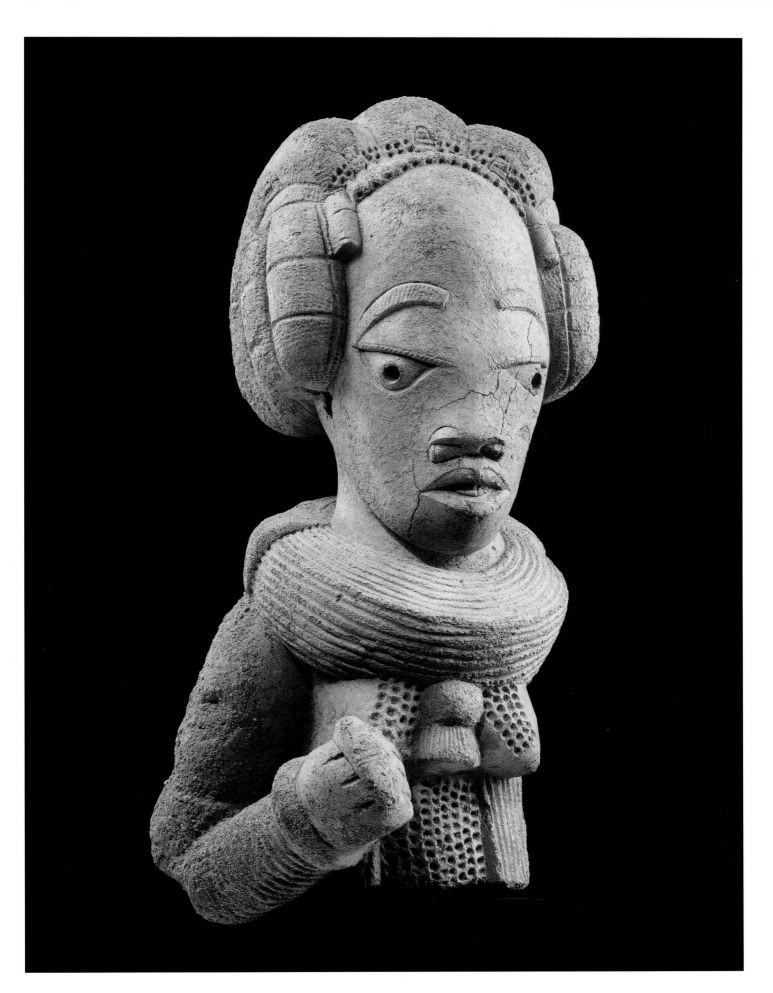

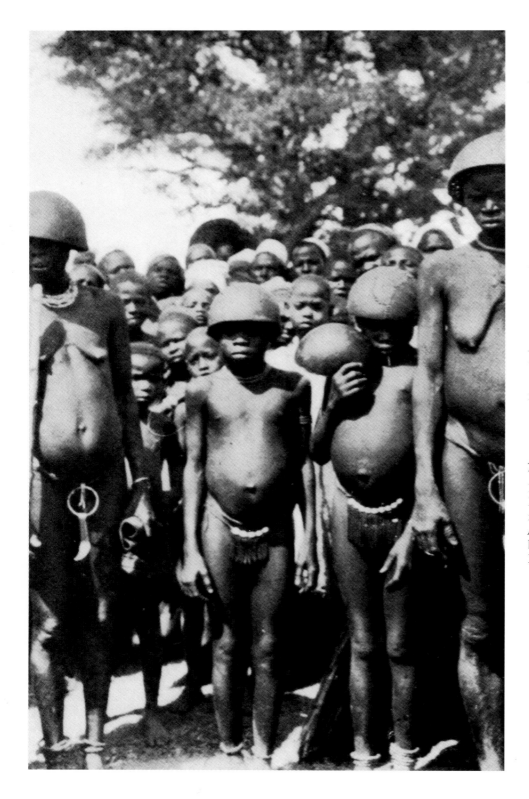

Opposte page:
21. MALE STATUETTE
ON BENDED KNEE ON
AN INVERTED VASE
Height: 15 inches
Date: TL 51201
(AD 150 ± 200 years)

Some of the headdresses could be representations of the calabash helmets that are still used by some groups in Nigeria and along the border of Cameroon, such as the Kirdi. Bernard Fagg published an old photograph by A. L. Calverts, *The Cameroons,* in which the hair was sculpted into the shape of a brimmed hat.

Left:
TUR WOMEN from the Bauchi plateau in Nigeria. Published in *Tribal Studies in Northern Nigeria*, by Charles K. Meek, New York, 1950, p. 320.

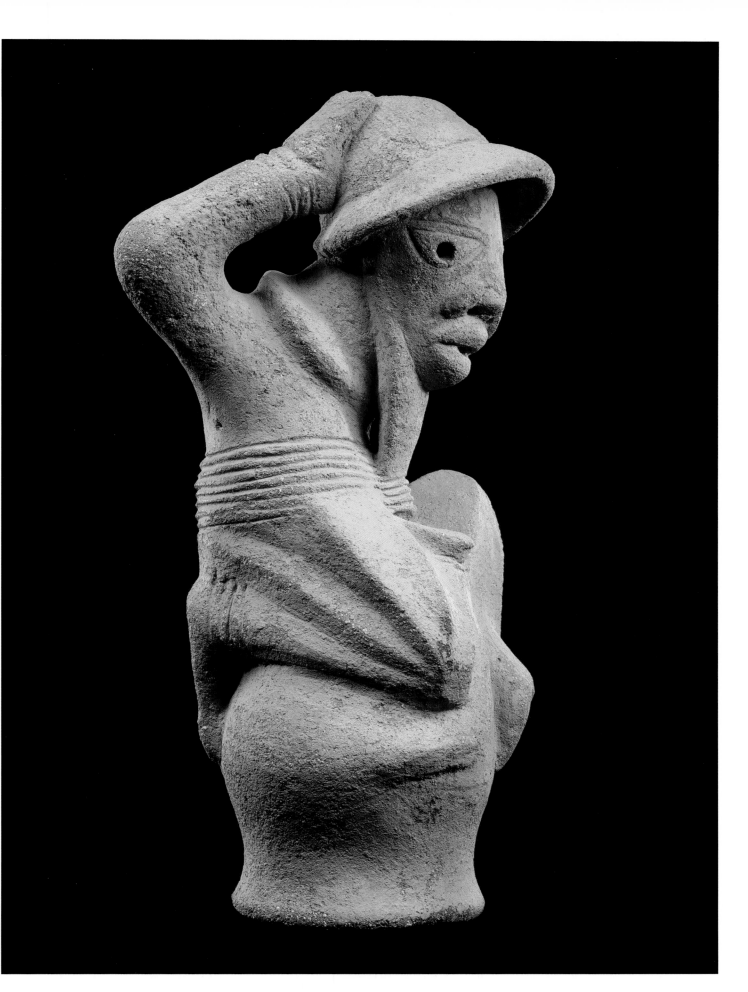

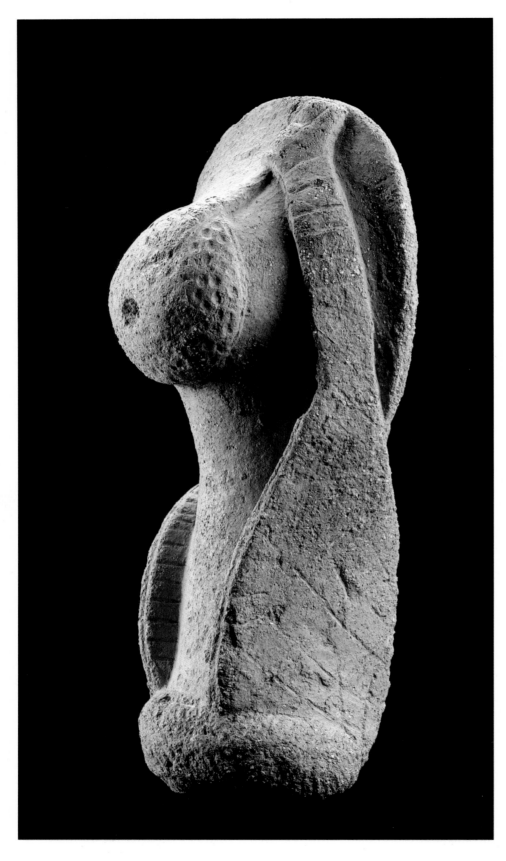

22. MALE BUST
Height: 14 inches
Date: TL 12175
(450 BC ± 250 years)

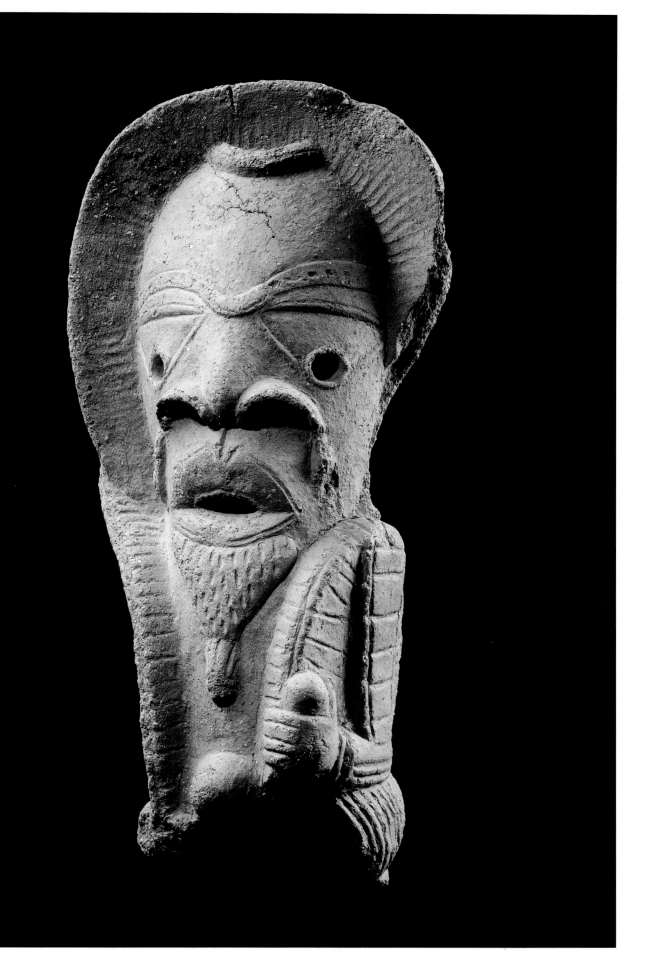

Below:
BRONZE IJEBU STATUE, eighteenth century, 27 inches high, National Museum of Lagos, published in *L'art Nègre, Sources, Évolution, Expansion,* Dakar-Paris, 1966, n° 193.

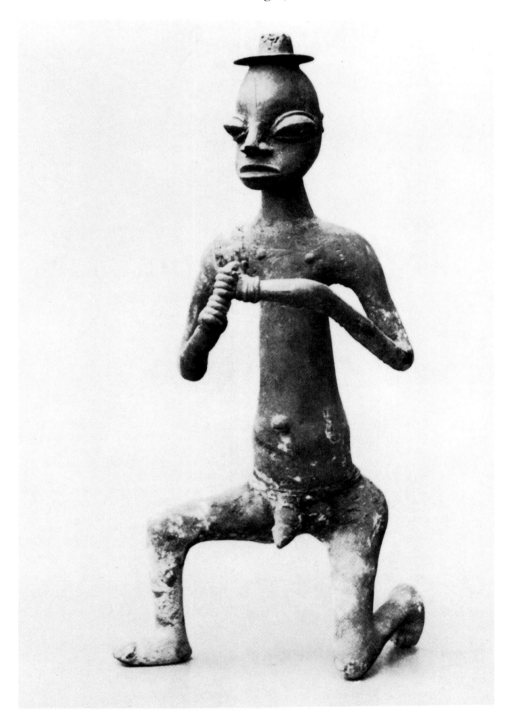

Opposite page:
23. MALE STATUETTE ON BENDED KNEE ON A VASE
Height: 17 3/4 inches
Date: TL 11304
(AD 250 ± 250 years)

There is a wide diversity in Nok composition. Many statues are represented on bended knee. We can compare the pose of the statue on the opposite page to this one of a bronze Ijebu statue, which is probably from the eighteenth century. It is one of the rare portrayals of this pose in Yoruba art, created more than one thousand years after the disappearance of the Nok culture.

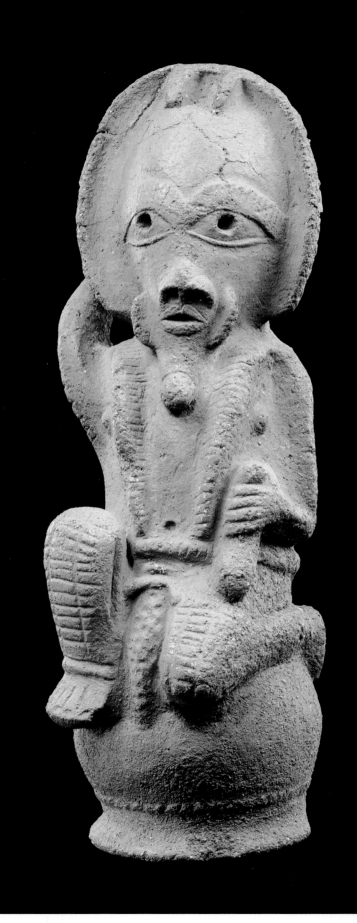

Below:
24. CROUCHING
PENDANT STATUE
Height: 12 inches
Date: TL 610265
(250 BC ± 200 years)

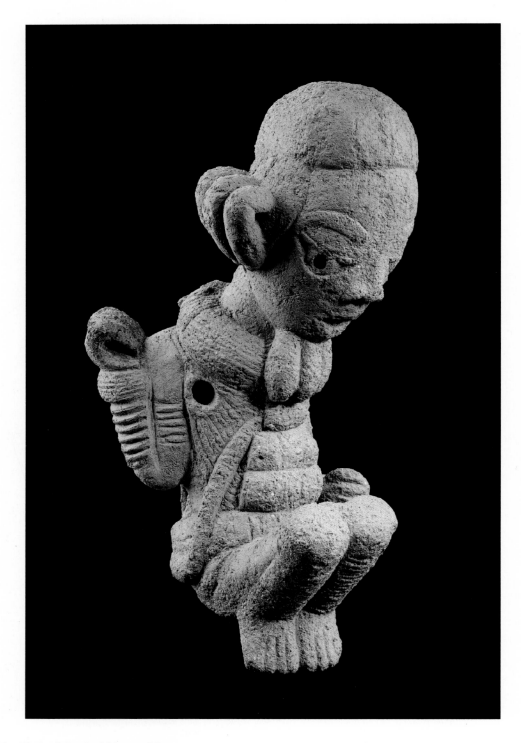

Opposite page:
25. CROUCHING
PENDANT STATUETTE
Height: 5 3/4 inches
Date: TL 807 223
(350 BC ± 250 years)

These sculptures both have a hole drilled between the folded arm and the right elbow, which means that they were meant to be hung. One is certainly an amulet, as it is small, but the other is too large to be worn around the neck. The position of the raised right arm is also found in Kongo statuary; a large number of nail fetishes feature a similar pose.

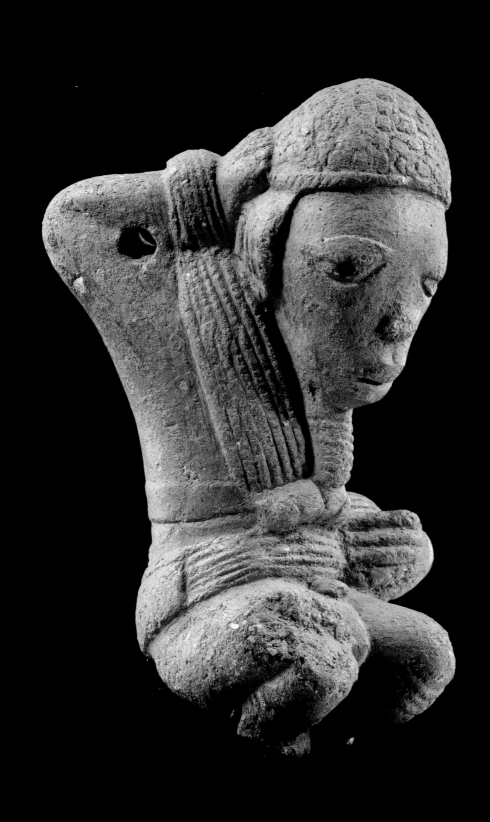

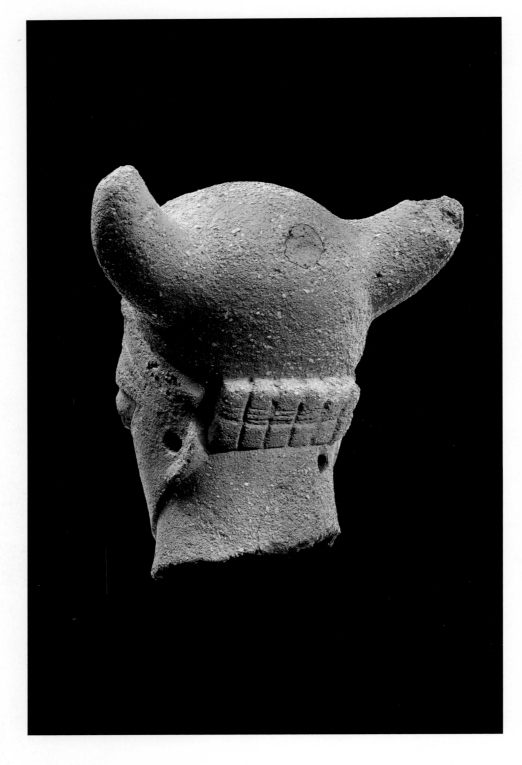

26. HEAD WITH
HORNED HELMET
Height: 11 inches
Date: TL 9208
(50 BC ± 200 years)

The horned helmet is a rare type of headdress in Nok art. Horned helmets made of leather are used by some groups in Nigeria today.

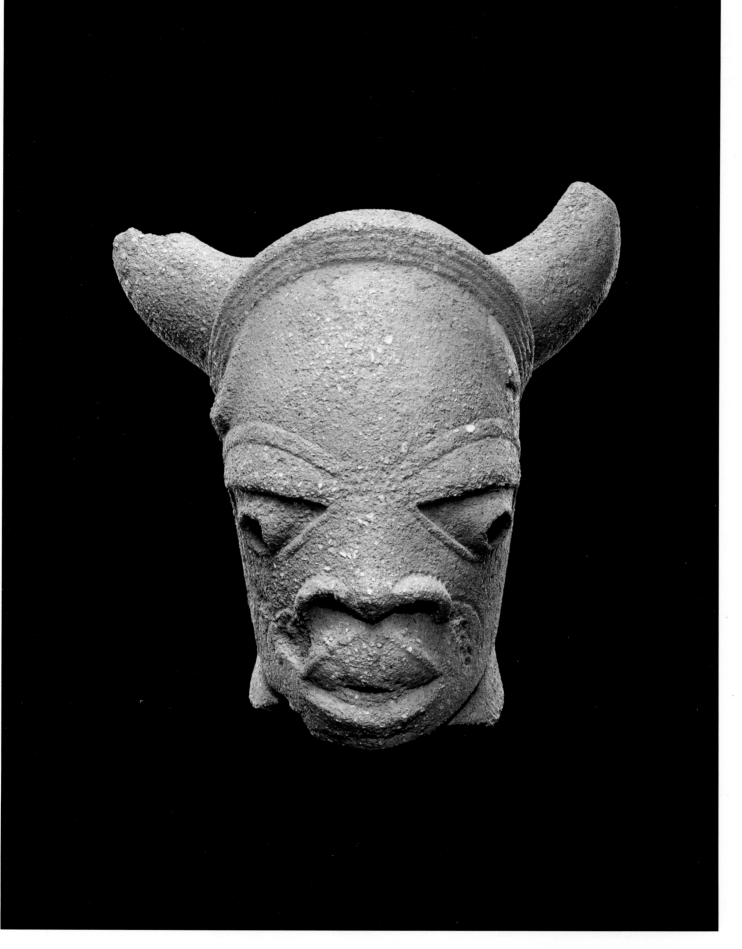

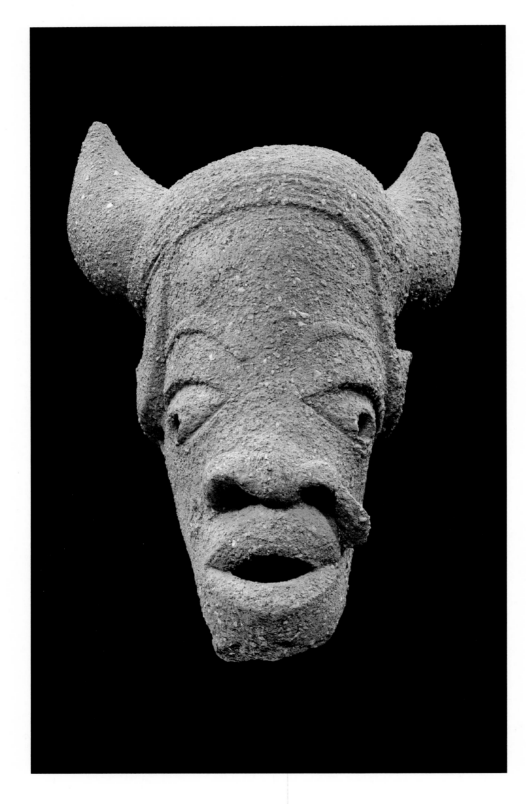

Left:
27. HEAD WITH
HORNED HELMET
Height: 9 1/2 inches
Date: TL 12047
(150 BC ± 200 years)

Opposite page:
28. HEAD WITH
HORNED HELMET
Musée Barbier-Mueller,
Geneva
n° 1015-103
Height: 12 1/2 inches
Date: TL 581r77
(350 BC ± 500 years)

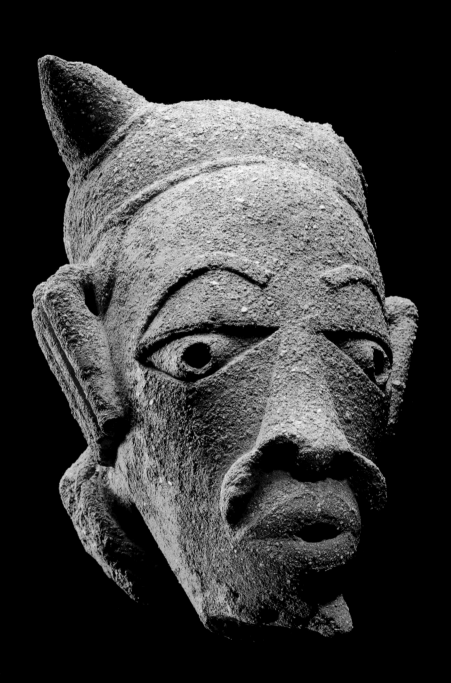

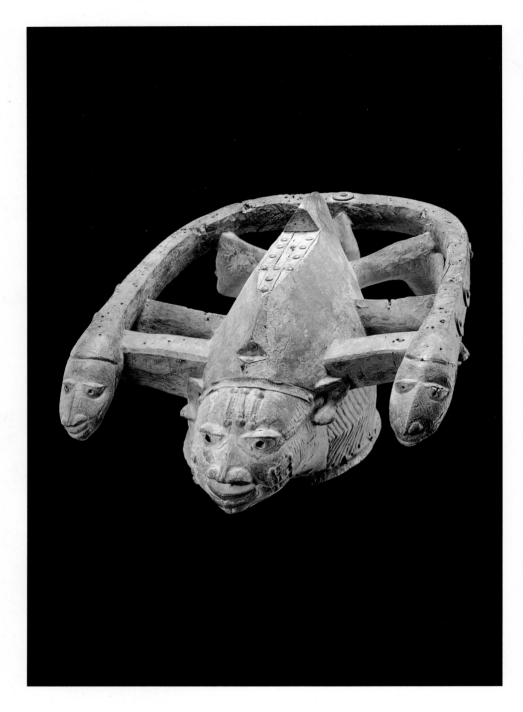

Opposite page:
29. HEAD
Height: 9 inches
Date: TL 704184
(250 BC ± 200 years)

We have illustrated this remarkable Yoruba mask alongside a Nok head to demonstrate the stylistic continuity that exists between the two styles of art. This wooden helmet-mask, probably from the nineteenth century, has holes in the pupils, a characteristic detail of Yoruba masks. There is no practical reason for these holes, as the mask was simply placed on the head of the dancer; the holes were not used to see through, as the mask did not cover the face. This stylistic characteristic was a simple artistic convention which has been handed down by the Nok sculptors to the Yoruba artists of the last century.

Above:
Fig. 3: YORUBA MASK
Length: 29 7/8 inches
Date: nineteenth century

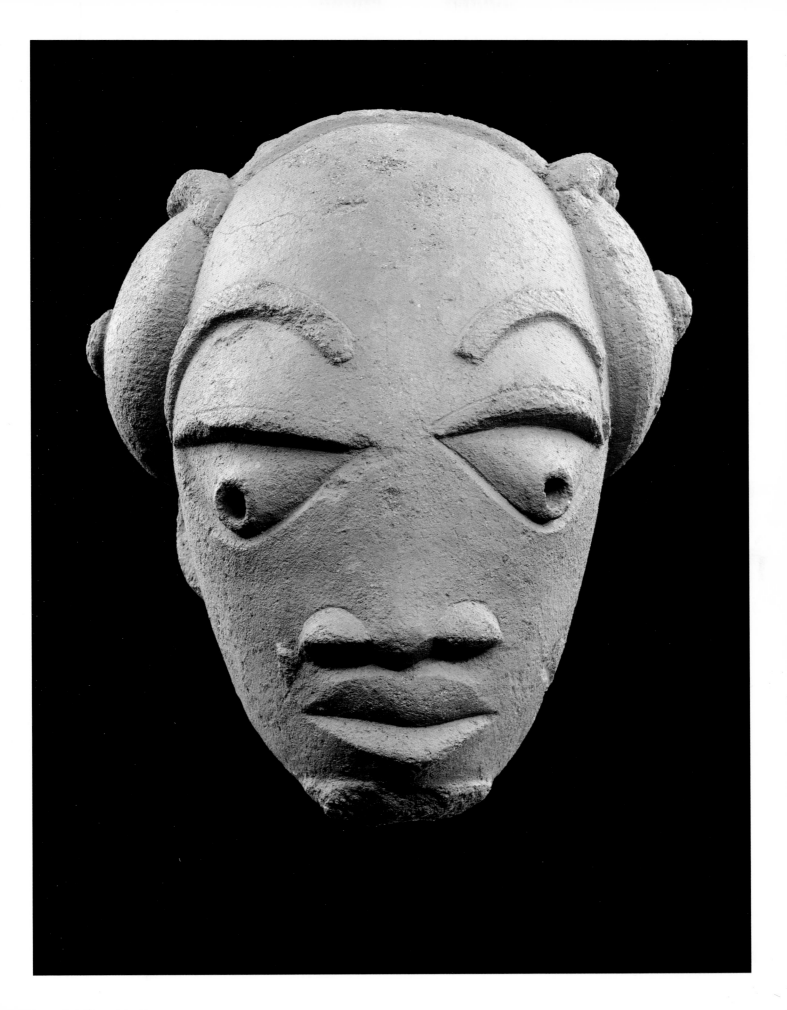

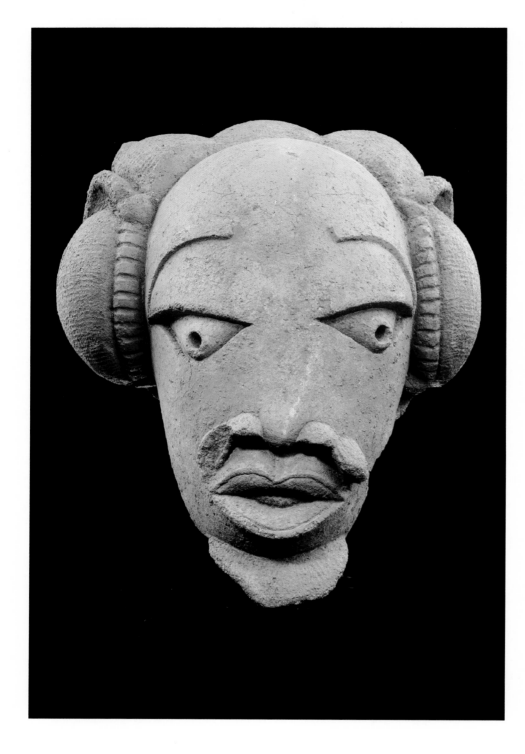

Left:
30. HEAD
Height: 9 inches
Date: TL 704182
(50 BC ± 200 years)

Opposite:
31. BUST
Height: 20 1/2 inches
Date: TL 510221
(250 BC ± 200 years)

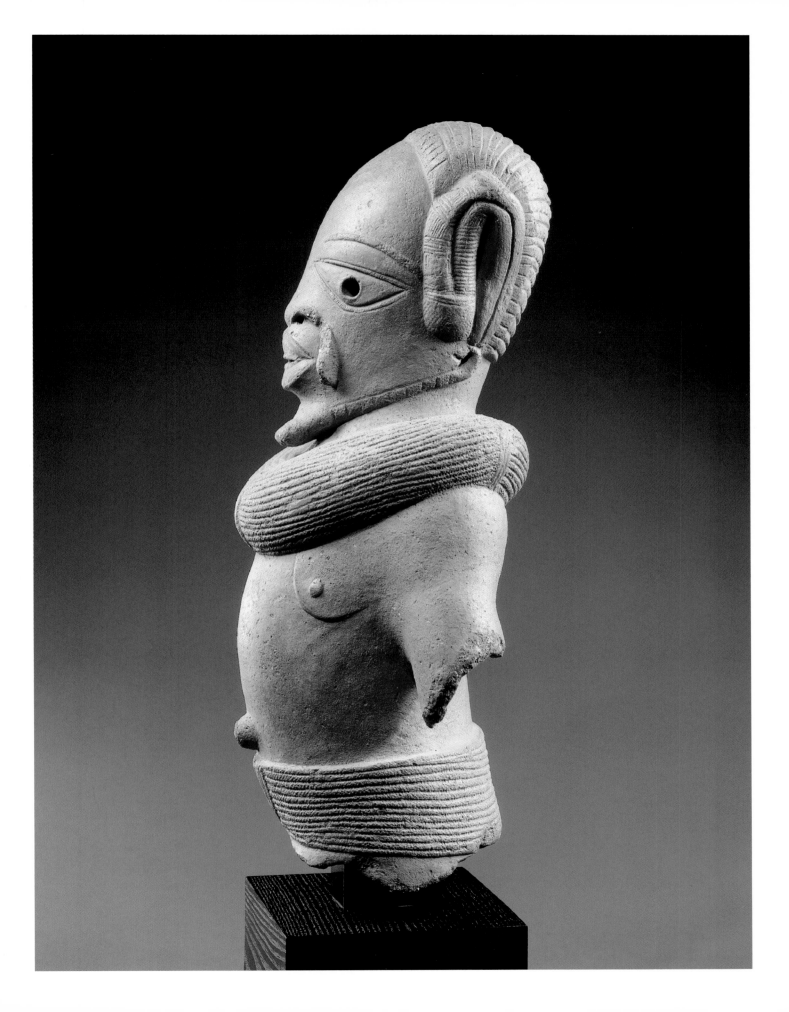

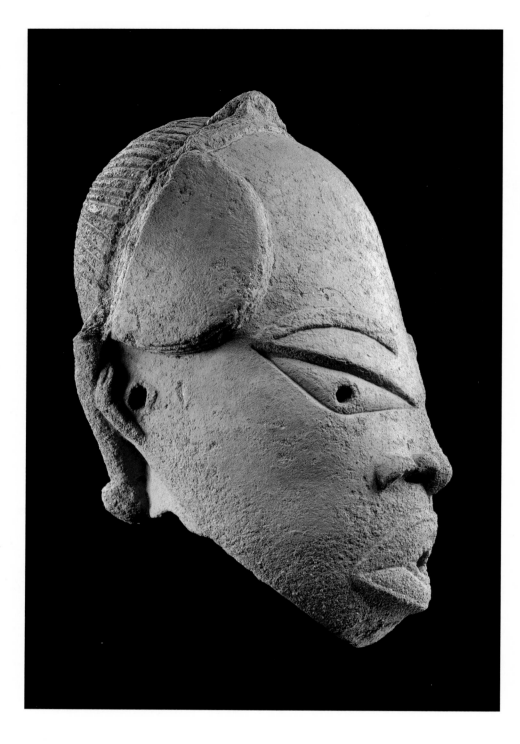

Left:
32. HEAD
Height: 13 1/3 inches
Date: TL 802188
(150 BC ± 200 years)

Opposite:
33. HEAD
Height: 14 3/4 inches
Date: TL 12174
(AD 200 ± 180 years)

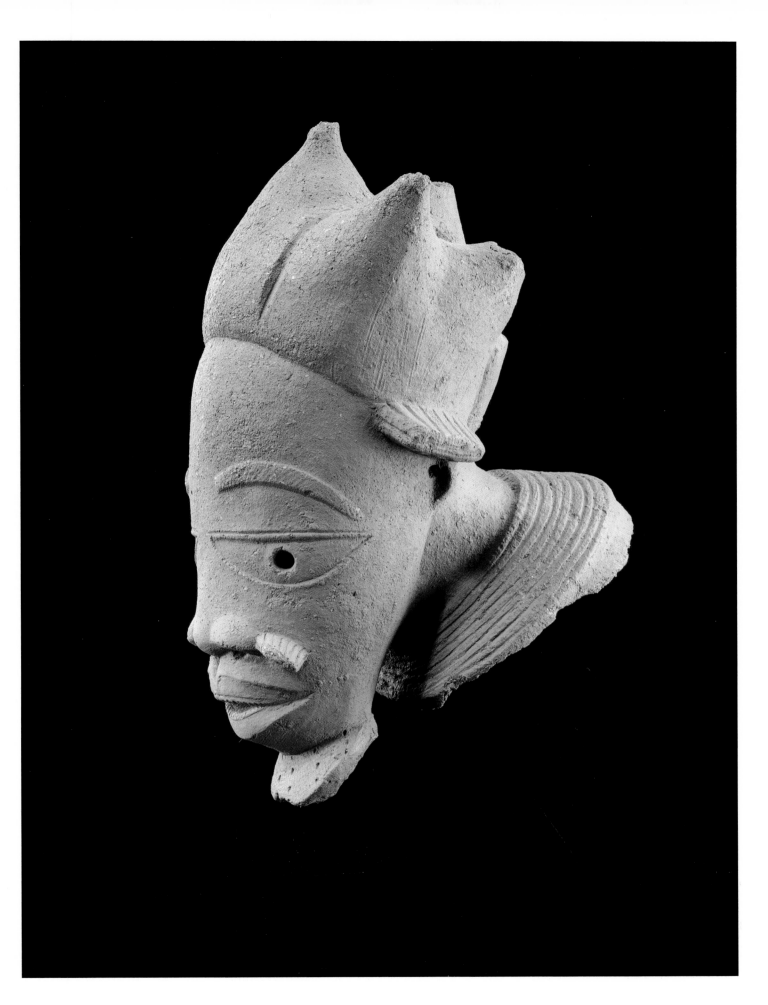

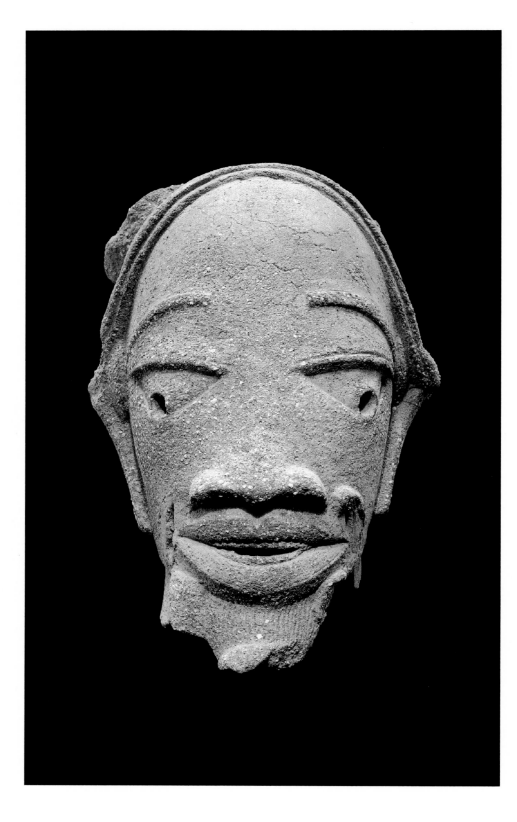

Left:
34. HEAD
Height: 11 3/4 inches
Date: TL 612211
(300 BC ± 200 years)

Opposite page:
35. BUST
Height: 19 2/3 inches
Date: TL 7242
(250 BC ± 200 years)

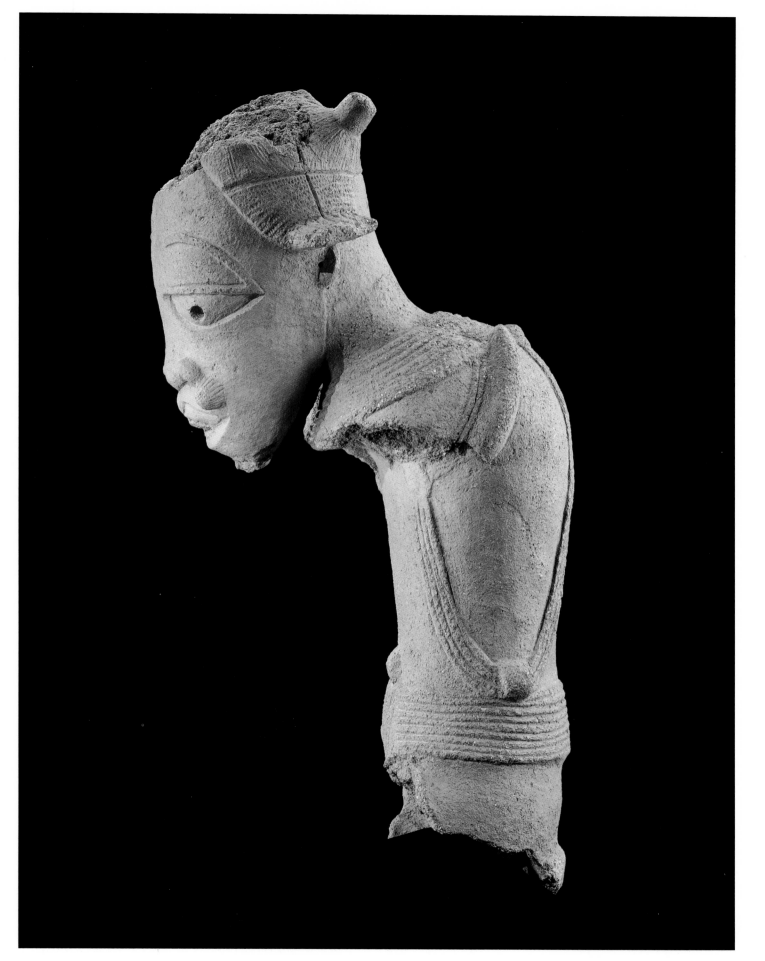

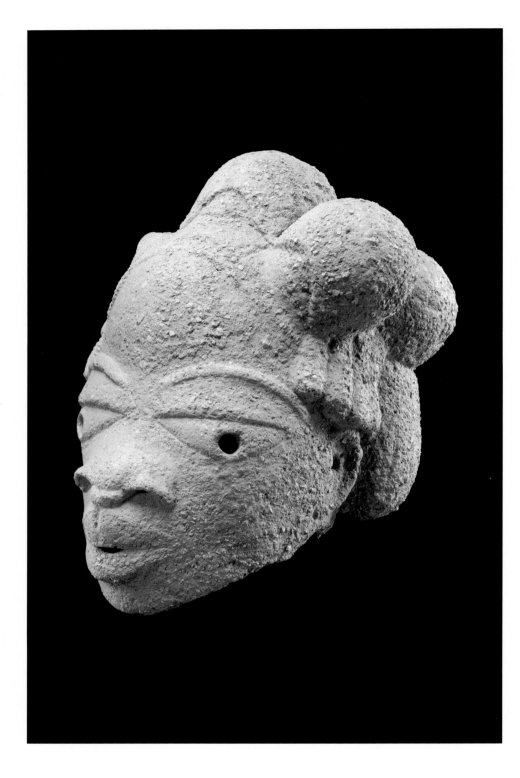

Left:
36. HEAD
Height: 11 inches
Date: TL 5097
(250 BC ± 200 years)

Opposite page:
37. HEAD
Height: 10 1/4 inches
Date: TL 9215
(350 BC ± 200 years)

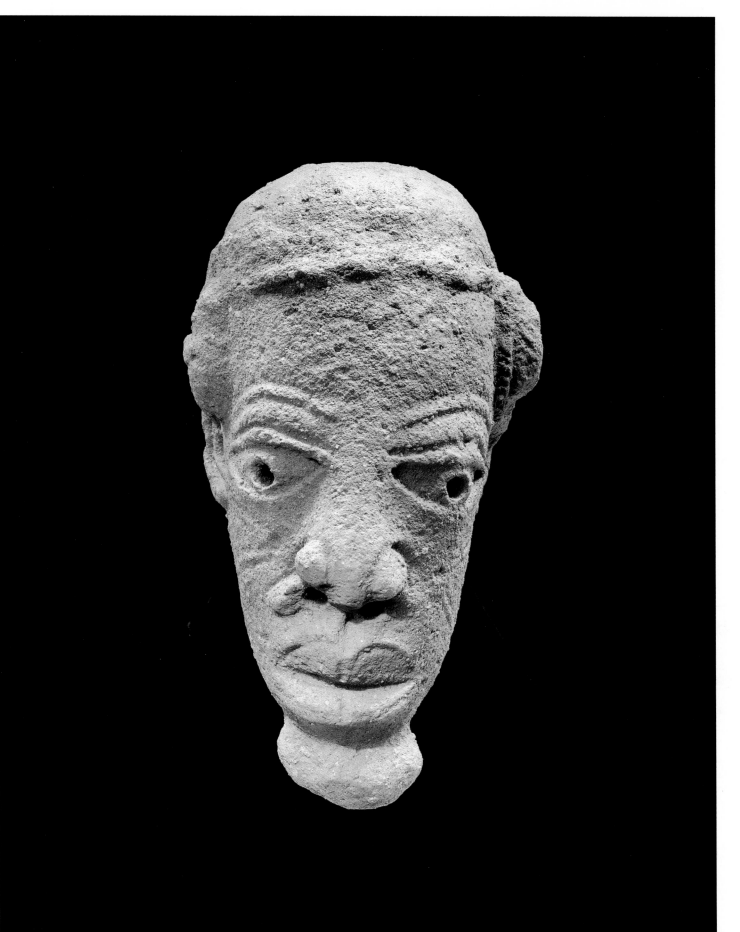

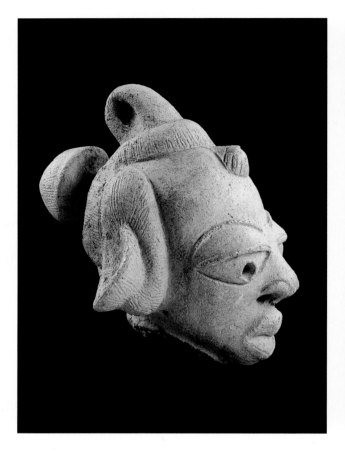

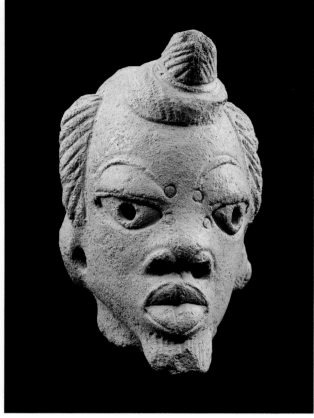

38. HEAD
Height: 7 7/8 inches
Date: TL 43280
(290 BC ± 200 years)

9. HEAD
Height: 8 1/4 inches
Date: TL 5087
(50 BC ± 200 years)

Opposite page:
40. HEAD
Height: 4 1/2 inches
Date: TL 51194
(250 BC ± 200 years)

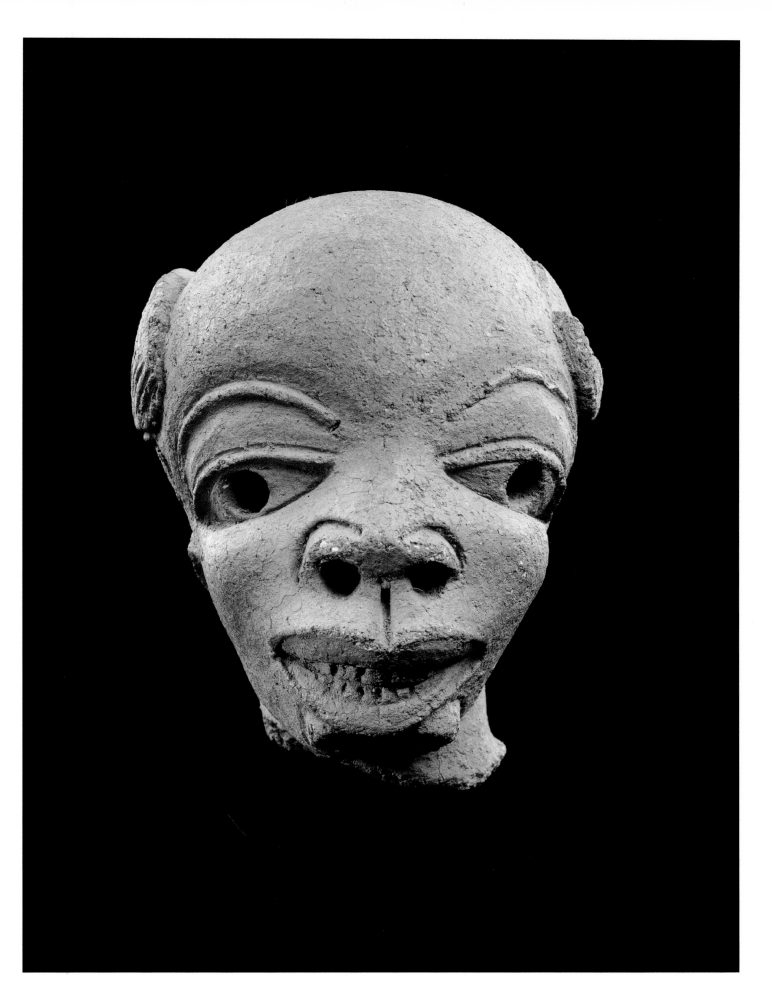

Right:
Fig. 5: JENNE AMULET
STATUETTE, Mali
Height: 3 1/2 inches
Date: TL 281r9
(AD 1470 ± 70 years)

Below:
Fig. 4: EPA YORUBA
MINIATURE MASK
Height: 7 inches
Date: Late nineteenth
century

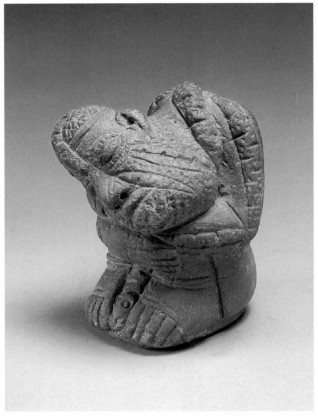

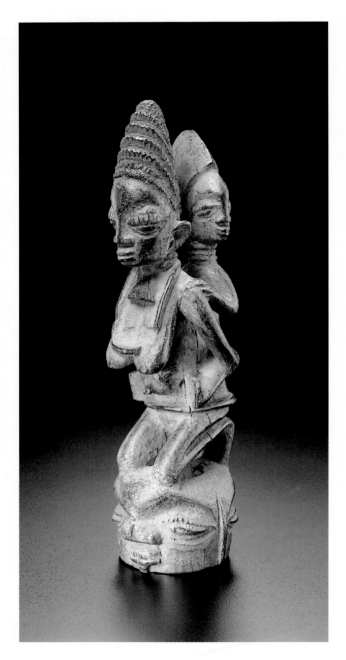

These amulets
are for the most
part miniature
representations of
large-size statues.
The concept of
statuette-amulets
seems widespread:
they are found among
the Jenne as well as
the Yoruba, where an
exceedingly rare
wooden modello of
an Epa mask (left).
These could measure as
much as seventy-nine
inches

Opposite page:
41. AMULET STATUETTE
Height: 5 1/8 inches
Date: TL 807 222
(350 BC ± 250 years)

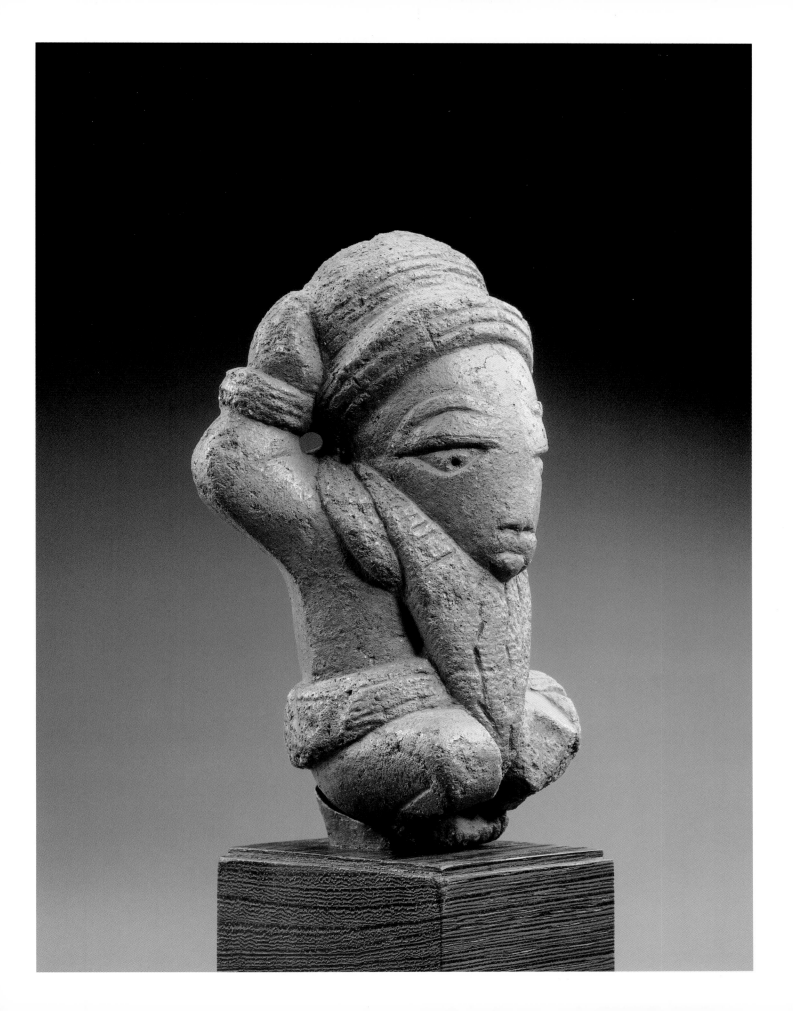

Below:
42. PAIR OF PENDANT
STATUETTES
Height: 4 inches
Date: TL 70534/2
(50 BC ± 200 years)

Above:
Fig. 6: LUBA ROYAL
CANE (detail), Congo
Height: 6 5/8 inches
Date: nineteenth
century

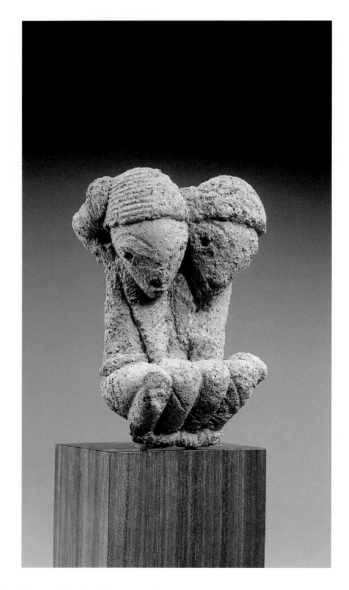

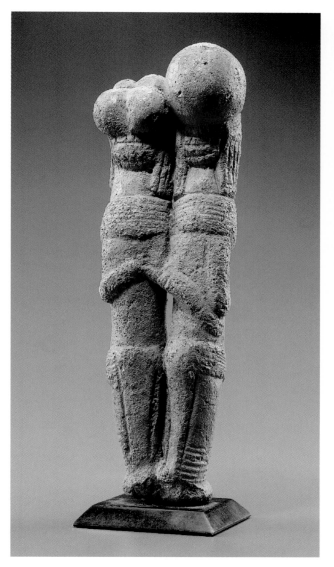

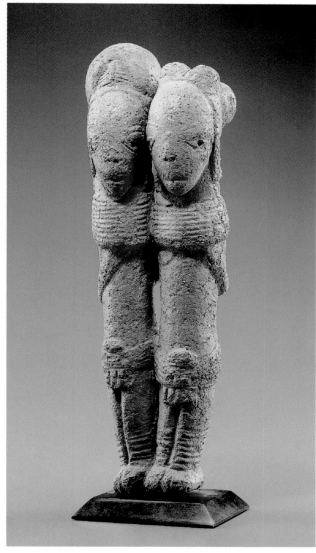

43. PAIR OF MINIATURE
STATUETTES
Height: 7 inches
Date: TL 704152/2
(250 BC ± 200 years)

The theme of the entwined couple appears in many styles in sub-Saharan Africa. It occurs in Jenne art in the thirteenth century and among the Dogons of Mali, in Kongo sculpture and in the royal Luba art in the eastern Congo (formerly Zaire). The detail on the back of this royal cane—a symbol of power among the Luba—also depicts two women with their arms behind their backs. This pose is similar to those of the two Nok pendants.

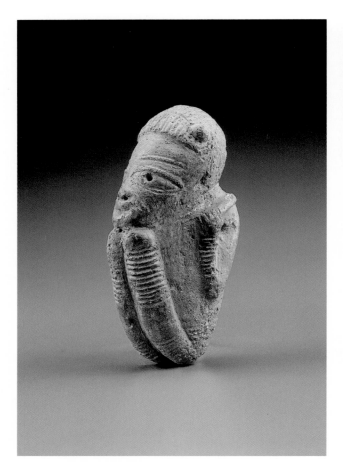

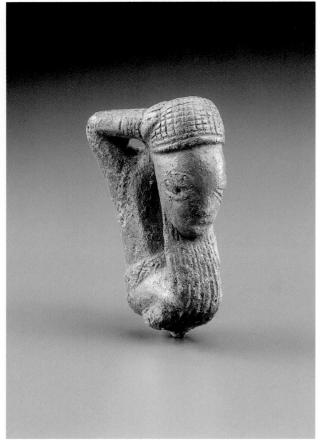

44. AMULET
Height: 4 1/3 inches
Date: TL 704152/1
(250 BC ± 200 years)

45. AMULET
Height: 3 1/2 inches
Date: TL 12180
(AD 350 ± 150 years)

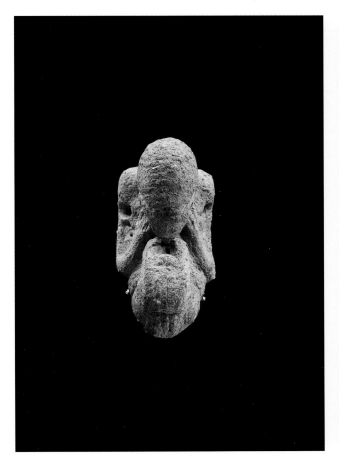

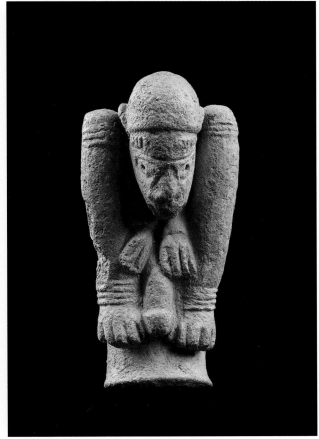

46. AMULET
Height: 3 1/8 inches
Date: TL 6250 3C
(250 BC ± 200 years)

47. MINIATURE
STATUETTE
Height: 7 inches
Date: TL 802187
(350 BC ± 200 years)

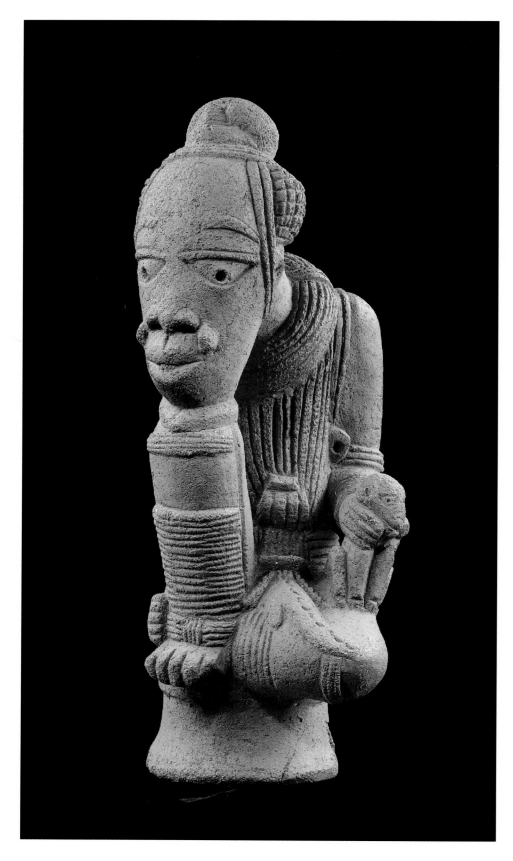

Left:
48. SEATED STATUE
HOLDING A FELINE
Height: 20 inches
Date: TL 712060
(150 BC ± 200 years)

Opposite page:
49. STATUE ON
BENDED KNEE WITH
ELEPHANT AND FELINE
Height: 16 1/2 inches
Date: TL 707124
(350 BC ± 200 years)

These two statues depict figures overpowering wild animals, a subject which introduces the complex relationships between humans and animals in art and ritual. These are obviously powerful figures—sorcerers or shamans—with connections to to both the animal kingdom and that of mankind. The relationship of power has been admirably rendered by the Nok artists, who represented dangerous animals as domesticated creatures under the total control of humans.

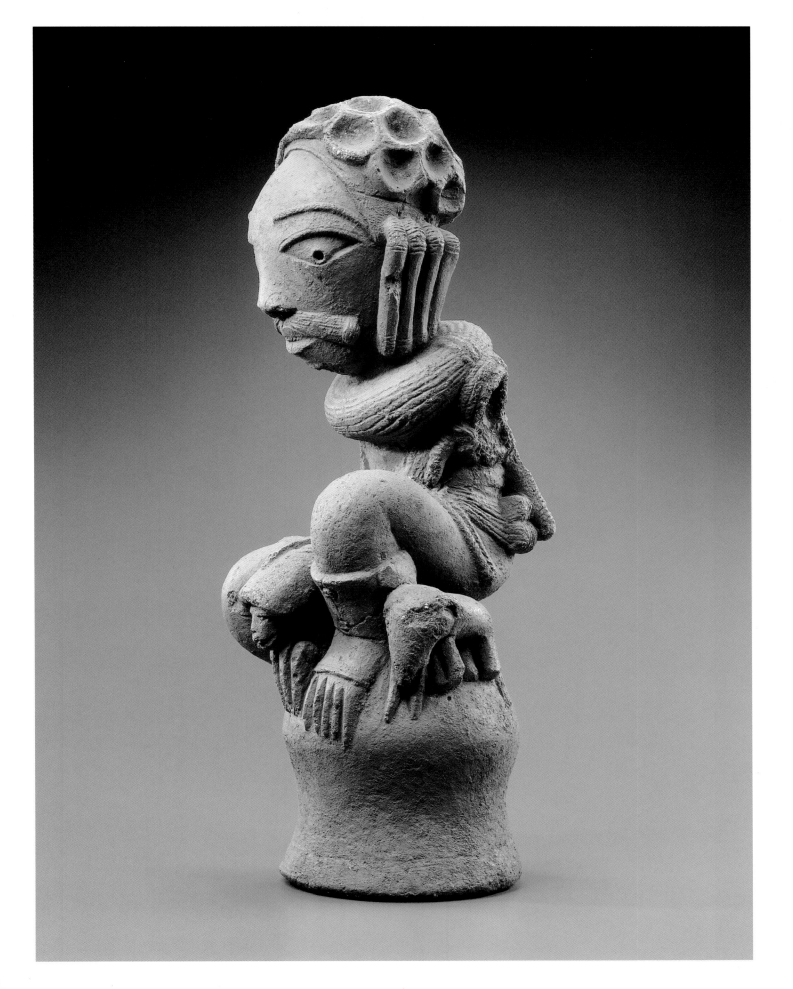

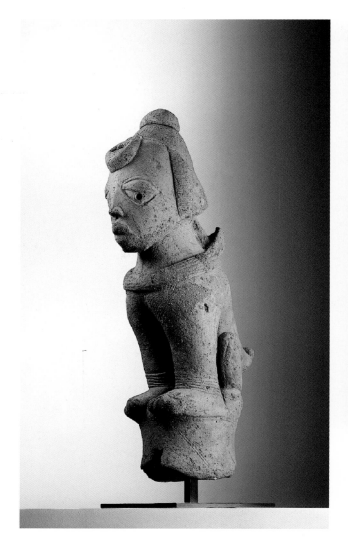

Fig. 7: SPHINX-MAN
Height: 17 3/4 inches
Date: TL 55 194
(AD 50 ± 200 years)

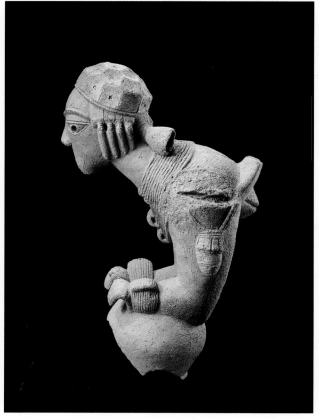

I refer the reader to the text on p. 23 relating to the remarkable sculptural work of the bird-man. Other fragments of bird-men have come up on the market. The theme of the sphinx-man also appears in Nok art, as reflected in this strange statue of a human-headed feline (left).

Opposite page and above:
50. BIRD-MAN
Height: 18 1/2 inches
Date: TL 7234
(AD 250 ± 250 years)

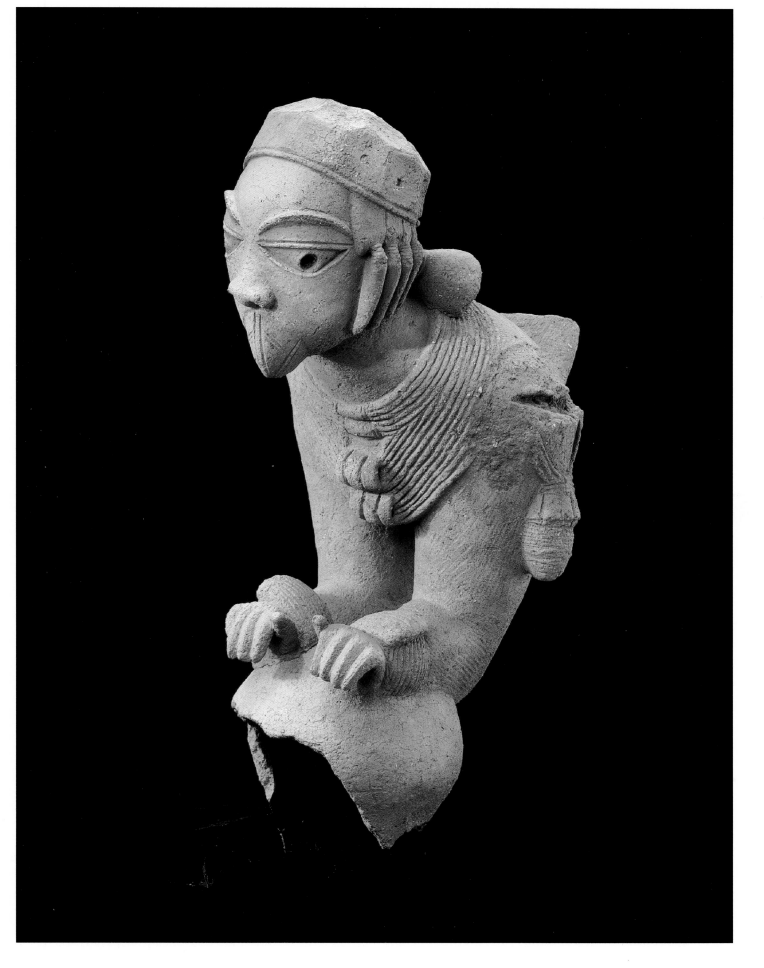

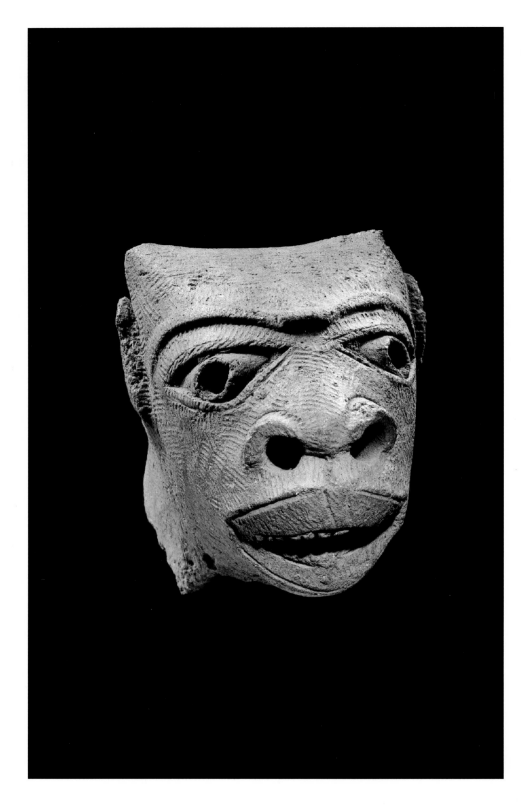

Left:
51. HEAD OF A
LEOPARD-MAN
Height: 6 1/3 inches
Date: TL 9210
(250 BC ± 200 years)

Opposite page:
52. TORSO
OF A LION CUB
Height: 8 1/4 inches
Date: TL 807 221
(400 BC ± 200 years)

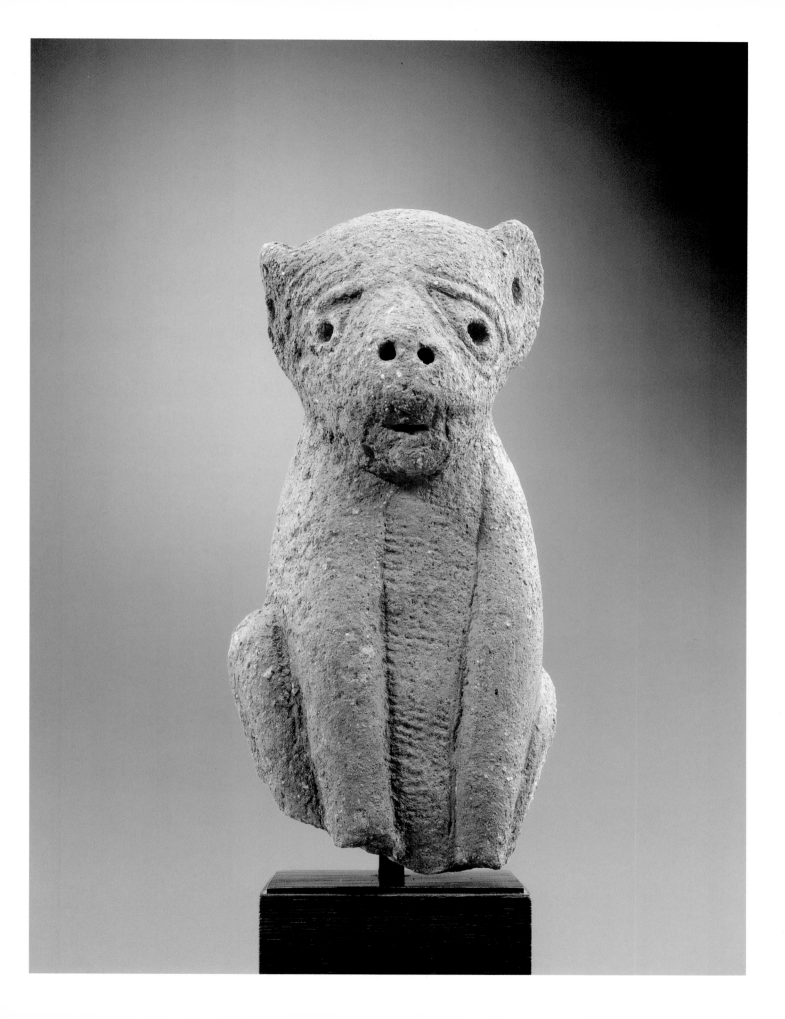

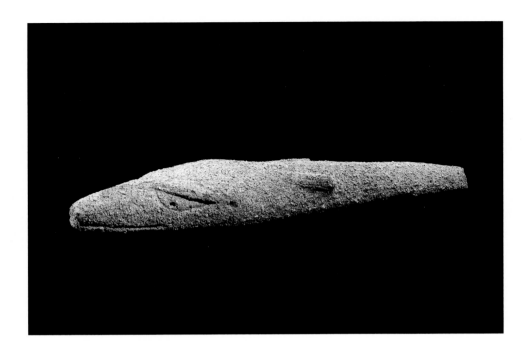

Below:
53. ELEPHANT
Height: 7 1/2 inches
Date: TL 703284
(50 BC ± 200 years)

Above:
54. CATFISH
OR SERPENT
Length: 11 5/8 inches
Date: TL 807211
(300 BC ± 200 years)

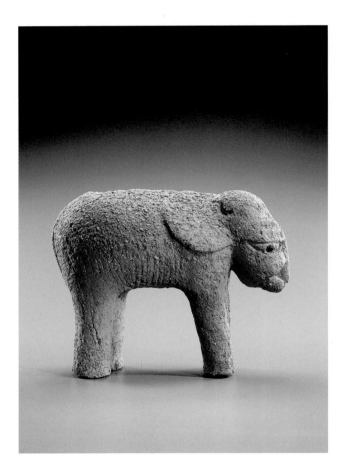

Opposite page:
55. BUST
WITH SERPENT
Height: 18 7/8 inches
Date: TL 703011
(250 BC ± 200 years)

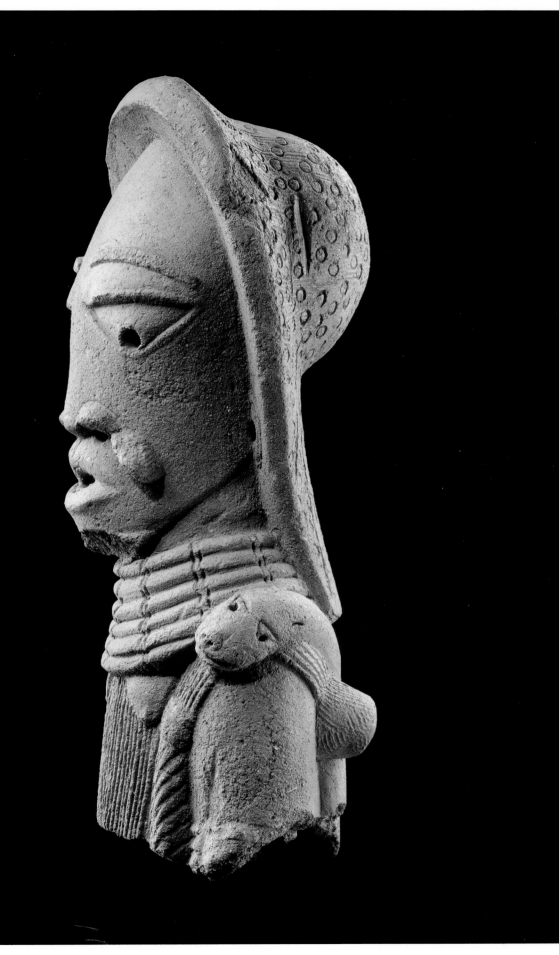

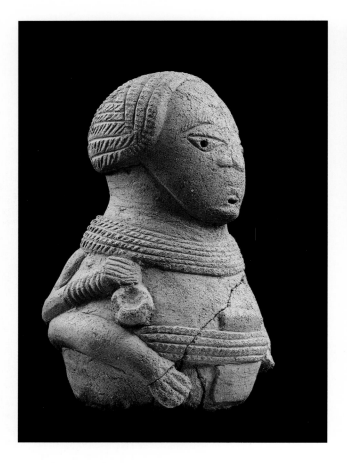

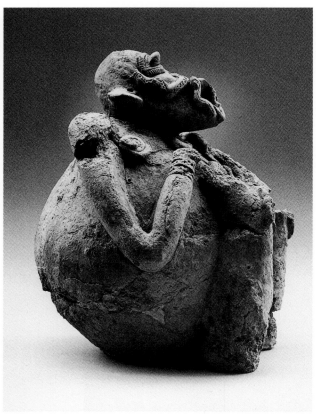

Above left:
56. ANTHROPOMORPHIC
RITUAL VASE
Height: 11 3/8 inches
Date: TL 712053
(250 BC ± 200 years)

We wanted to stress the formal similarities between certain Nok ritual vases (left) and those from the civilization that existed on the inner delta of the Niger River in Mali (right) between the tenth and the seventeenth centuries.

Above right:
Fig. 8: JENNE
ANTHROPOMORPHIC
VASE, Mali
Height: 18 1/2 inches
Date: TL 281a23
(AD 1165 ± 30 years)

Opposite page:
57. YELWA-STYLE
STATUETTE
Height: 7 5/8 inches
Date: TL 710226
(20 BC ± 200 years)

This standing statue is similar to another one found at the Yelwa site along the Niger, in the Sokoto province. The style, which is contemporaneous with the Nok culture, may represent a more provincial or peripheral style than that of the classical style of the Jemaa.

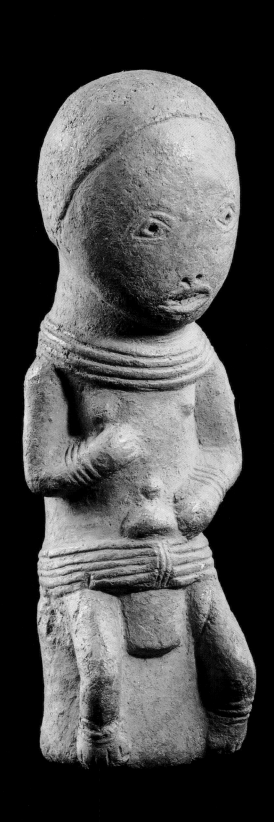

Below:
58. KATSINA HEAD
Height: 10 1/4 inches
Date: TL 610186
(150 BC ± 200 years)

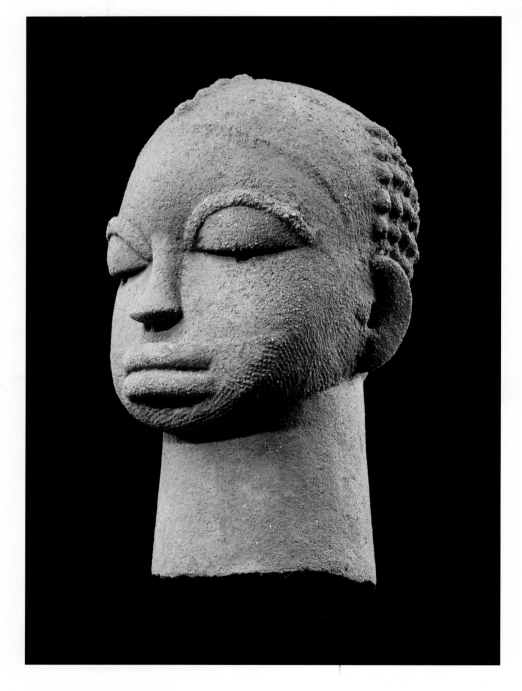

Opposite page:
59. KATSINA BUST
Height: 12 5/8 inches
Date: TL 610268
(150 BC ± 200 years)

These two beautiful fragments illustrate the obvious plastic qualities of Sokoto art, which, although it does not have the refined elegance of Nok art, sometimes achieves a similar level of quality.

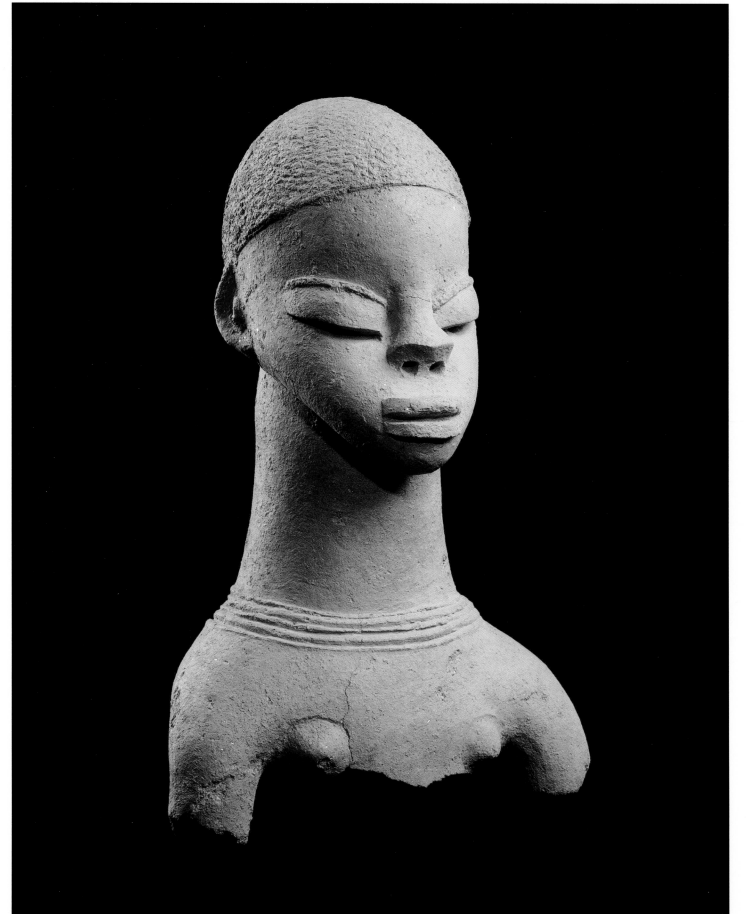

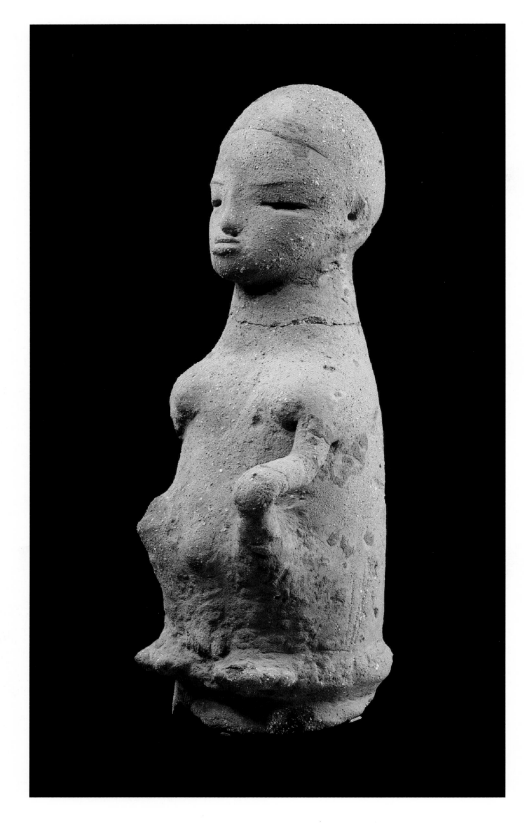

Left:
60. KATSINA STATUE
Height: 13 1/3 inches
Date: TL dart/1994/175
(50 BC ± 200 years)

Opposite page:
61. KATSINA MALE
STATUE
Height: 18 1/2 inches
Date: TL 705162
(250 BC ± 200 years)

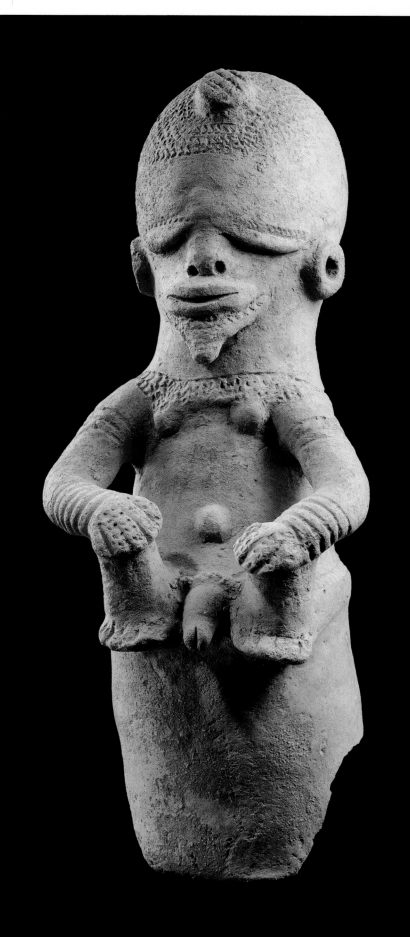

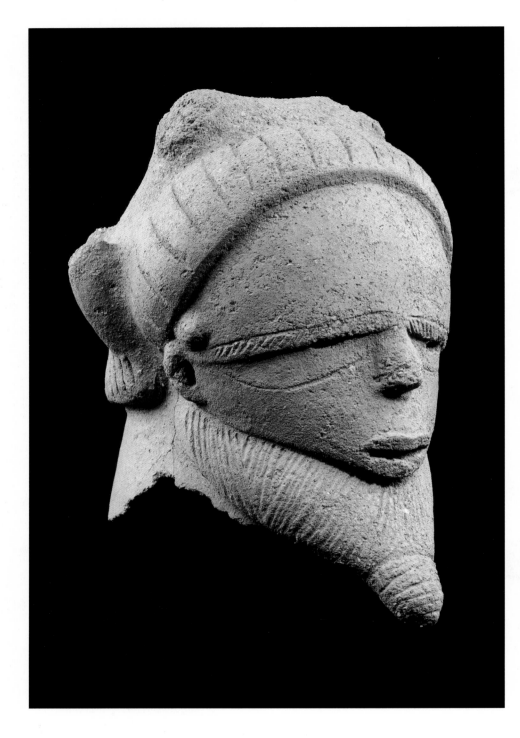

Left:
62. SOKOTO HEAD
Height: 10 1/4 inches
Date: TL 6166
(350 BC ± 170 years)

Right:
63. SOKOTO MALE
BUST
Height: 20 7/8 inches
Date: TL 5061
(AD 50 ± 200 years)

The Sokoto style was also contemporaneous with Nok art, but it comes from areas situated farther to the north and perhaps west of the Nok region. This style seems to have little formal connection with Nok art; it would be difficult to mistake a Sokoto head for a Nok head. The only similarities we can find concern the helmet-masks from the Igala kingdom.

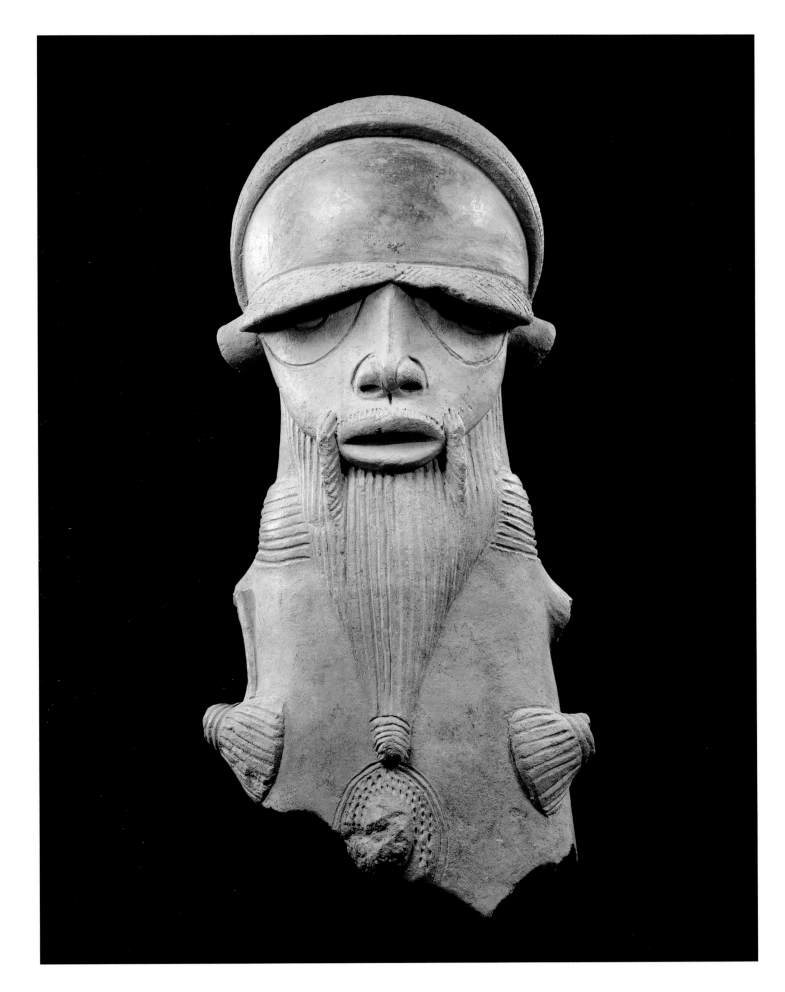

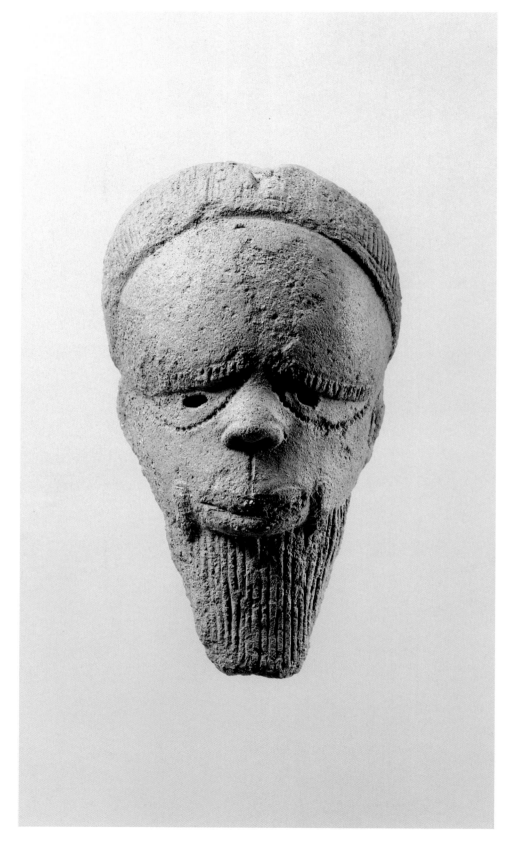

Left:
64. SOKOTO HEAD
Musée Barbier-Mueller,
Geneva,
n° 1015-93
Height: 8 5/8 inches
Date: TL 250 BC ± 200
years

Opposite page:
65. SOKOTO HEAD
Height: 13 inches
Date: TL 710222
300 BC ± 200 years

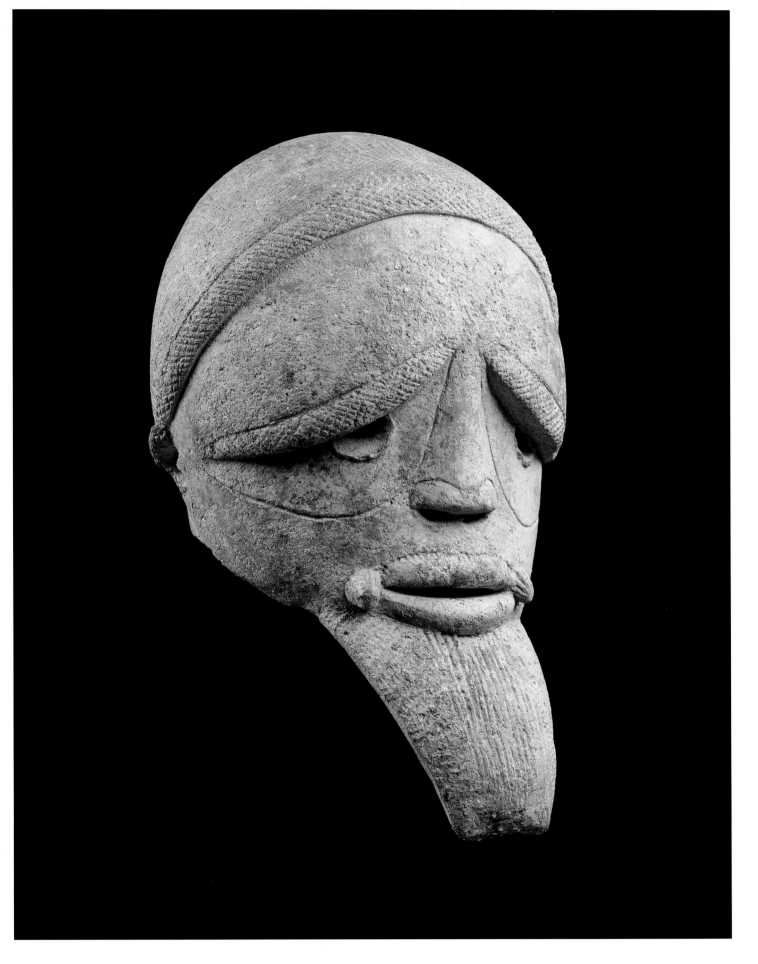

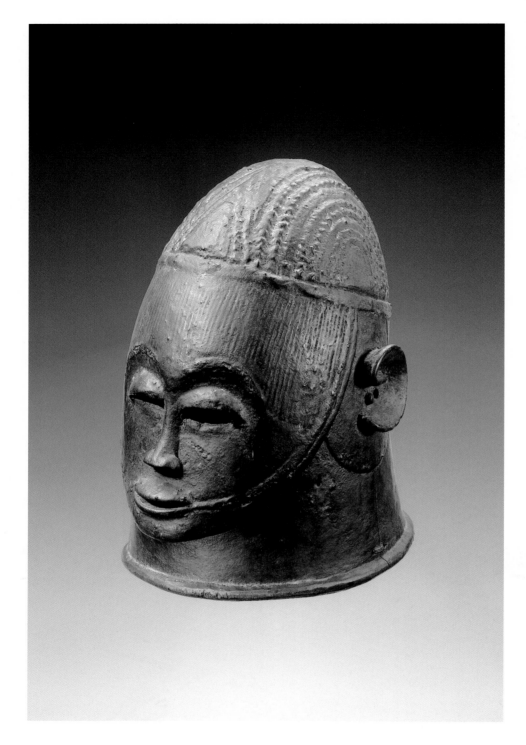

Left:
Fig. 9: IGALA ROYAL
MASK
Height: 12 1/8 inches
Date: nineteenth
century

Opposite page:
66. SOKOTO HEAD
Height: 9 5/8 inches
Date: TL 41160
(250 BC ± 200 years)

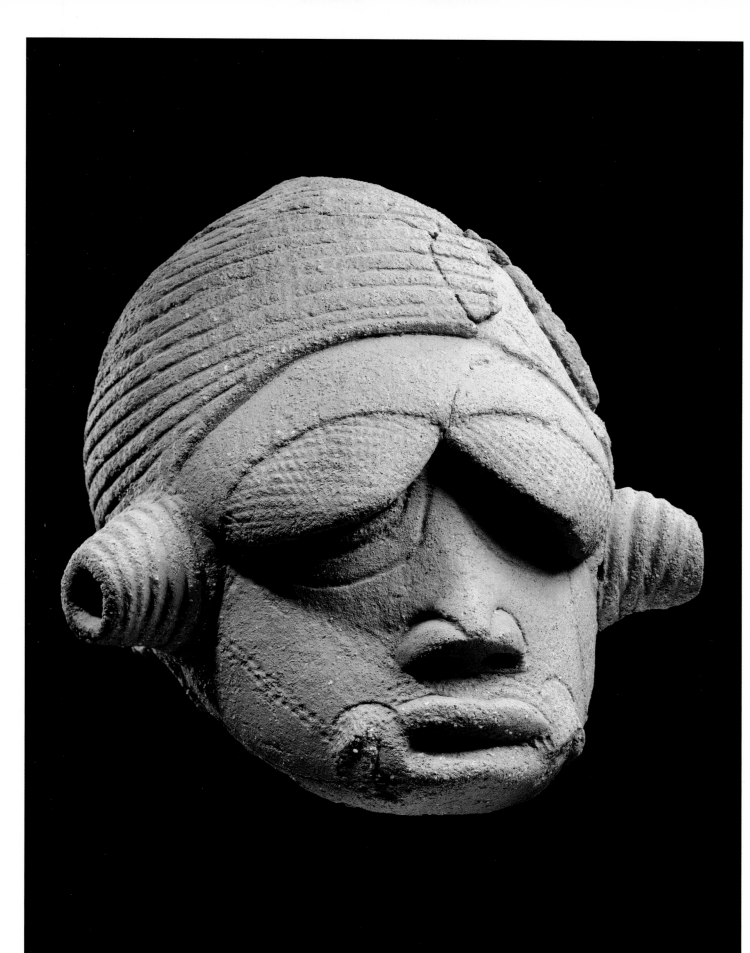

DATING OF ANCIENT CIVILIZATIONS FROM NIGERIA

The sculptures in this catalogue are a representative sample from the oldest cultures from West Africa: the Nok, Sokoto and Katsina cultures. Since the discovery in the past few years of new archaeological sites, interest in these cultures has increased. There is little information on these extraordinary cultures and many questions remain unanswered. Only chemical and physical analysis and in particular dating can provide some answers to the numerous questions raised by these ancient civilizations.

Dating by Thermoluminescence

The technique of dating by thermo-luminescence is mainly used for objects made of fired clay (also called terracotta). In the case of clay, it is the crystals of feldspars and quartz included in the clay which are dated. There is one crucial condition: the clay piece must be fired at a minimum of 500°C in order to set back the natural clock to zero.

Luminescence is the emission of light by certain crystals when they are submitted to an external source of energy. In the case of thermo-luminescence, this source of energy is provided by heating. This heating process provokes the emission of all the light stocked during geological time in the crystalline structure of a clay piece. By heating the same clay piece a second time, at a much later date, a certain amount of light is emitted. The amount of light emitted is directly proportional to the amount of time between each heating process. It becomes an image of time.

Sample preparation

As in all dating techniques, one needs to collect samples (a few grams are sufficient) for thermoluminescence. Each sample is ground, washed by chemicals and placed on small discs on which the luminescent signal is counted.

It is crucial to inspect carefully every terracotta piece before collecting a sample. This inspection allows the laboratory to choose the appropriate zone for sampling. Depending on the size of the piece, one should take at least two samples from the least exposed parts of the object. By comparing curves obtained from different samples of the same piece, one can not only relate the object to other ones from the same culture but also verity any restorations or reconstruction.

The annual dose

Luminescence of crystals is a complex phenomenon which is intimately connected with the amount of radiation absorbed. This radiation comes mainly from natural radioactive isotopes such as uranium, thorium and potassium which are present not only the clay but also in the surrounding natural environment. Radioactive elements slowly decay in time. This process can take billions of years before to see the radioactive elements completely disappear. The decrease of radioactivity is so slow that it does not affect the dating of terracotta objects which are only a few thousand years old. One speaks then of a constant annual radiation dose for any piece buried in the ground. This dose is calculated by measuring the quantities of uranium, thorium and potassium in the clay and in the natural environment.

The archaeological dose

In order to date the last firing of a clay object, one needs to know the natural dose of radiation received since this last firing. In order to calculate this dose, one measures the luminescence of the sample by heating it in a laboratory. Two series of thermo-luminescence curves are obtained: the first

from discs allowing measurement of the natural thermoluminescence (Nat) and the second from additional thermoluminescence induced by artificial irradiation (Nat+Gy). These artificial irradiation are created with perfectly calibrated radioactive sources. One speaks then of induced radiation. By comparing those various curves, one extrapolates a induced dose of radiation similar to the natural dose (Ill. 1). This dose is called the archaeological dose.

By simply dividing the archaeological dose by the annual dose, one can determine the age of the clay sample.

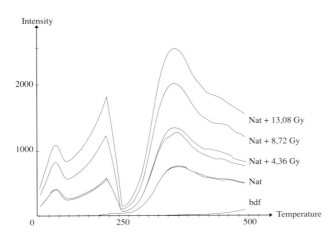

Ill. 1: *Typical glow curves by showing both natural thermoluminescence (Nat) and additional thermoluminescence induced by artificial irradiation (Nat+Gy).*

Authenticity tests

Under ideal conditions where the researcher knows all the physical variables of the surrounding soil, the uncertainty of thermoluminescence dating has an error limit of 5% of the age. However, with objects where the archeological context is unknown, the margin of error increased to 20%. It then becomes difficult to study the sediment which caused the natural radiation. The annual dose cannot be measured accurately. This dose is then approximated by the laboratory taking in consideration the period of the culture to which the piece belongs. One speaks then of authenticity test.

Results from thermoluminescence dating

In the case of the pieces published in this catalogue, it was not possible to have access to the archaeological sites. The analysis of sediments was not possible. One is thus much closer to authenticity tests than absolute dates. If the archeological dose can be accurately measured in laboratory conditions, for the annual dose on the other hand, one has to use arbitrary values. The dates for Nok terra-cottas range from 450 BC till 250 AD with an average annual dose of 4,5 mGy per year. (Ill. 2). Research on both the Sokoto and Katsina cultures allows us to conclude that all three cultures seem contemporary.

With our samples and a ± 20% margin of error, the distribution of dates can be visualized with a Gaussian curve (Ill. 3). In these conditions, it is possible to calculate that there is a 68% probability of the age of the Nok culture lying between 600 BC and 200 AD. If one considers error limits at 95% limit of probability, one can consider that the age stretches from 800 BC until 400 AD, lasting about 1200 years.

For more accurate results, two other conditions are necessary: the analysis of all sediment from the archaeological context of each terra-cotta sculpture and the dispatching of a scientific research team *in situ*. In order to obtain a unambiguous annual dose, a large number of measures of the environmental natural radio-activity is necessary. Only proper archaeological excavations will allow for more accurate thermo-

Opposite, Ill. 2: *Distribution of dates obtained for every piece in this catalogue, using an annual dose of 4,5 mGy per year and showing the simultaneity of both Nok, Sokoto and Katsina cultures.*

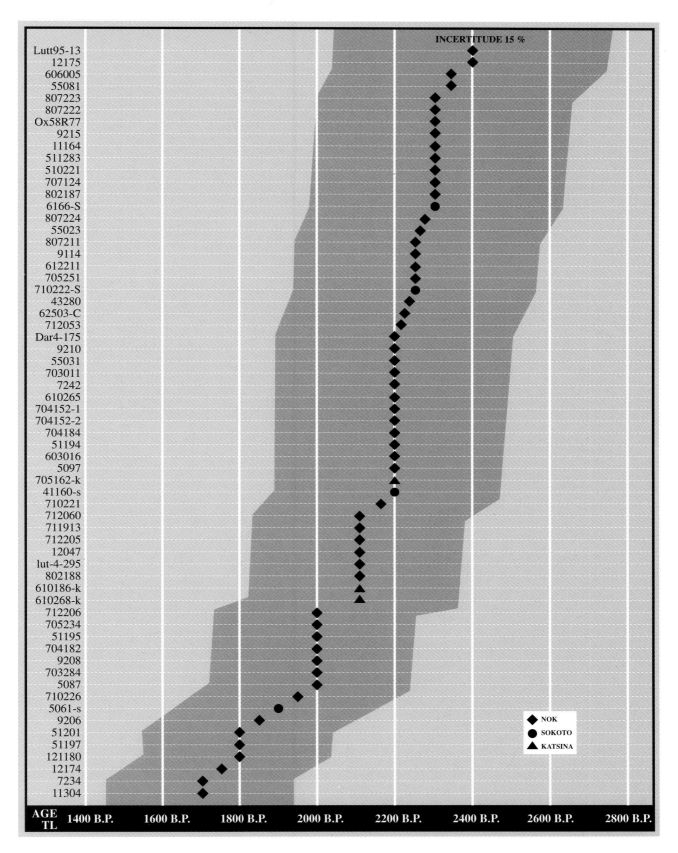

INCERTITUDE 15 %

		NOK
		SOKOTO
		KATSINA

AGE TL: 1400 B.P. 1600 B.P. 1800 B.P. 2000 B.P. 2200 B.P. 2400 B.P. 2600 B.P. 2800 B.P.

luminescence dates. However, other dating techniques can refine the chronology of these African cultures.

Carbon-14 dating

Like all radioactive elements, carbon-14 offers excellent dating results for organic matter. Carbon-14 comes from cosmic radiation and is found in the carbonic acid of the earth's biosphere. It is absorbed in living things by photosynthesis. One can assert that organic matter, while it is alive, is in equilibrium with the cosmic radiation, and all radiocarbon atoms that disintegrate in living things are replaced by new carbon-14 entering the food chain by photosynthesis. At the time of death, however, the assimilation process stops abruptly. The equilibrium is broken and the disintegration process takes over in an uncompensated manner. The concentration of radioactive elements will slowly diminish with time. According to the law of radioactive decay, after 5568 years, the carbon that was in the body while it was alive will show half the specific carbon-14 radioactivity that it showed previously. By comparing the concentration of carbon-14 of the sample with the initial concentration, one can measure the age of the sample.

Cross dating

In the course of our research, we were fortunate to discover inside some of the hollow Nok figures fragments of charcoal mixed with sediment. After various analyses and dating of the charcoal by carbon-14, we concluded that the charcoal and the terracotta figures were contemporary. The presence of charcoal inside these objects can be explained by the use of a wooden armature for structural support of the unfired figure. This phenomenon is quite exceptional and it allowes us to date Nok figures by using both thermoluminescence and carbon-14 methods. One talks then about cross dating.

Results of the carbon-14 analysis

For carbon-14 dating, it is not necessary to know some of the physical parameters of the environment in the archaeological site as it is for thermoluminescence. The errors limits after calibration are almost non-existent and the results are much more accurate. One can then speak of truly absolute dates for the Nok culture. After calibration, the period for Nok art spans from 1000 BC until 300 BC.

These dates overlap more or less those results obtained by thermoluminescence. However, one notices a shift between the Gaussian curve of the distribution of dates by carbon-14 and the curve by thermoluminescence. (Ill. 3). This shift results in a variance of a few hundred years. This shift does not mean that thermoluminescence as a method is flawed. It entails diminishing the value of the standard annual dose used all the laboratories for the calculation of dates.

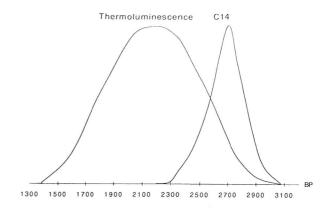

Ill. 3: *Comparison of the Gaussian curve of the distribution of dates by carbon-14 of fifteen Nok pieces and the Gaussian curve of dates by thermoluminescence of all the Nok pieces in this catalogue, using a margin of error of 20%. One see clearly the shift between both curves which justifies choosing a lower value for the annual dose.*

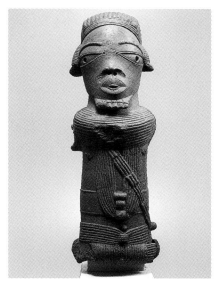

Nok Torso
Height: 25 1/4 inches
Date:
Age C14 n° SMA 18627, 1010-810 BC
Age TL n° 59105: 650-150 BC

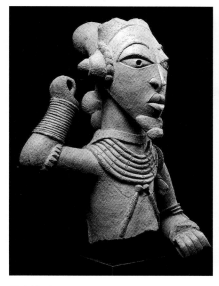

Nok Bust
Height: 19 3/4 inches
Date:
Age C14 n° SMA 14893: 810-511 BC
Age TL n° 55087: 620-180 BC

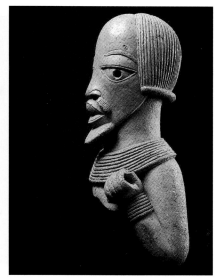

Nok Torso
Height: 14 1/4 inches
Date:
Age C14 n° SMA 18628: 914-766 BC
Age TL n° 922-15: 600-100 BC

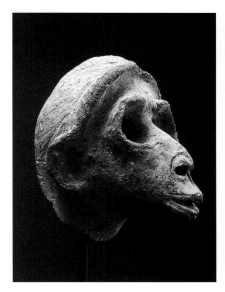

Nok Animal head
Height: 5 1/2 inches
Date:
Age C14 n° SMA 18625: 915-792 BC
Age TL n° 287: 620-180 BC

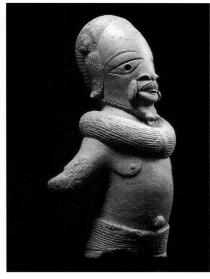

Nok Bust
Height: 21 inches
Date:
Age C14 n° SMA 18626: 850-755 BC
Age TL n° 510221: 530-70 BC

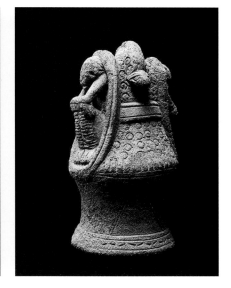

Nok Vase
Height: 7 7/8 inches
Date:
Age C14 n° SMA 14894: 390-198 BC
Age TL n° 56261: 400-0 BC

Pieces of charcoal from the burned inside framework of a Nok statue, found with sediment.

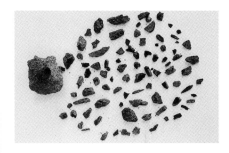

Conclusion

In the absence of written sources and organized archaeological excavations, only the increase in dating both by thermoluminescence and carbon-14 will permit us to better understand the ages of the Nok, Katsina and Sokoto cultures. Due to the lack of sediment, dates obtained by thermoluminescence are not completely accurate. It is thanks to carbon-14 dates from the charcoal inside terra-cotta objects that the uncertainty of the true age can be diminished.

The first results by carbon-14 are encouraging and the results seem to push back the date of this culture. If these results are confirmed, the entire chronology of some ancient civilizations from West Africa need to be revised. These cultures may have begun earlier, at the beginning of the third millennium before Christ.

FRANCINE MAURER,
ASA (Aliance Science Art)
OLIVIER LANGEVIN,
Physicist specializing in archaeology

CAPTIONS FOR COMMON POSES IN NOK STATUARY

1. STANDING

I/a. Female figure, arms folded along her body, hands placed on either side of her breasts.

I/b. Male figure holding a scepter in his left hand, right hand along the length of his torso.

I/c. Male figure holding a scepter in his right hand, left hand along the length of his torso.

I/d. Male figure, right arm raised, left arm along the length of his torso.

I/e. Male figure, right arm folded in front of his torso, left hand placed low over his stomach.

II. SEATED

Figure on an inverted delta-shaped chair, with both knees pulled up against the chest, chin resting on crossed arms placed on the kneecaps.

III. SEATED

III/a. Figure on an inverted delta-shaped or inverted vase-shaped chair, knees pulled up against the chest with crossed arms resting on them, head raised high.

III/b. Figure on an inverted delta-shaped or inverted vase-shaped chair, knees pulled up against the chest with arms placed on the kneecaps, head raised high.

IV. ON BENDED KNEE

IV/a. Figure on an inverted vase-shaped chair, with the right knee pulled up against the torso, left knee bent, right arm raised, left arm along the length of the body.

IV/b. Figure on an inverted vase-shaped chair, with the right knee pulled up against the torso, left knee bent, right arm touching the edge of the headdress, left arm along the length of the body.

IV/c. Figure on an inverted vase-shaped chair, with the right knee pulled up against the torso, left knee bent, right arm placed on the length of the body, left arm holding a scepter.

IV/d. Figure on an inverted vase-shaped chair, with the right knee pulled up against the torso, left knee bent, right arm placed on the right kneecap, left arm resting on the left ankle.

IV/e. Figure on an inverted vase-shaped chair, with the right knee pulled up against the torso, left knee bent, both arms bent, hands placed over the breasts.

V. ON BENDED KNEE

V/a. Figure on an inverted vase-shaped chair, with the left knee pulled up against the torso, right knee bent, right arm raised, left arm along the torso.

V/b. Figure on an inverted vase-shaped chair, with the left knee pulled up against the torso, right knee bent, both arms placed along the torso.

VI. SEATED

Figure on an inverted delta-shaped chair, chin resting on the right knee pulled up against the torso, left knee bent.

VII. SEATED

Figure on an inverted delta-shaped chair, chin resting on the left knee pulled up against the torso, right knee bent.

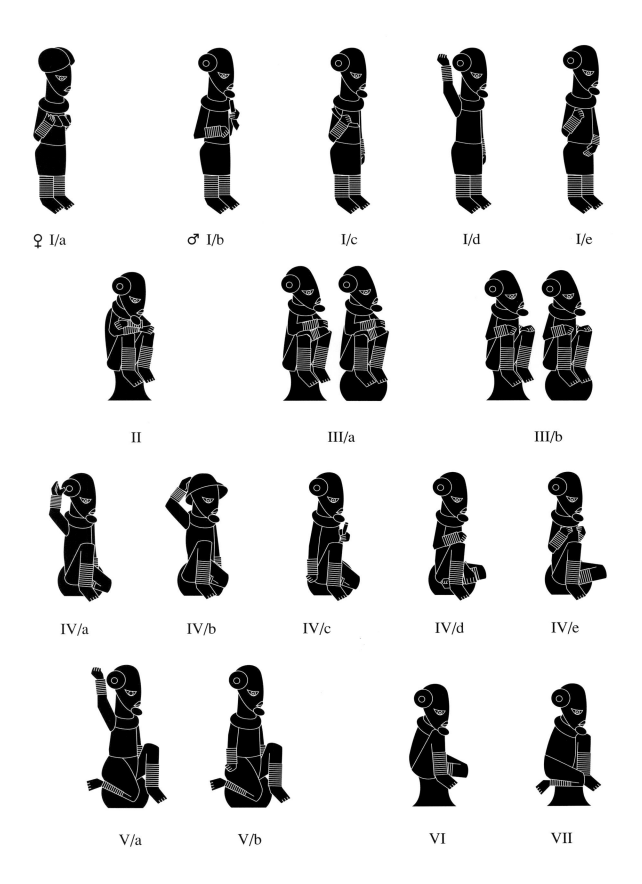

♀ I/a ♂ I/b I/c I/d I/e

II III/a III/b

IV/a IV/b IV/c IV/d IV/e

V/a V/b VI VII

BIBLIOGRAPHY

ALLEMAND, Maurice, *L'Art de l'Afrique noire et l'époque nègre de quelques artistes contemporains*, Saint-Étienne, musée d'Art et d'Industrie, 1956.

BATULUKISI, Niangi, "Pré- et protohistoire de la région kongophone", in Félix, Marc, *Art & Kongo*, Zaïre Basin Art History Research Center, Brussels, 1995, p. 17-42.

BEN-AMOS, Paula, "The Powers of Kings: Symbolism of a Benin Ceremonial Stool", in Ben-Amos, Paula et Rubin, Arnold, *The Art of Power The Power of Art*, Museum of Cultural History, UCLA, Los Angeles, 1983, p. 51-58.

BITIYONG, Yashim Isa, "Cultures Nok", Nigeria, in *Vallées du Niger*, Paris, Réunion des musées nationaux, 1993, p. 393-413.

BORBEIN, Adolph H., "Polykleitos", in Palagia, Olga and Pollitt, Jerome J., *Personal Styles in Greek Sculpture*, Cambridge, Yale Classical Sudies, 1997, p. 66-90.

BOULLIER, Claire, *Les Sculptures en terre cuite de style Nok: approche pluridisciplinaire*, mémoire de DEA, Paris, université de Paris I-Panthéon, 1995-1996.

BURLEIGH, Robert *et al.*, "British Museum natural radiocarbon measurements IX", in *Radiocarbon*, vol. XIX, n° 2, 1977, p. 154-155.

CHAMOUX, François, *La Civilisation grecque*, Paris, Arthaud, 1963.

CHARBONNEAUX, Jean, *La Grèce classique*, Paris, NRF, "L'Univers des formes", 1969.

COULIBALY, Élisée AND CHIEZE, Valérie, "Histoire du fer", in *Vallées du Niger*, Paris, Réunion des musées nationaux, 1993, p. 334-342.

DUCHATEAU, Armand, *Bénin Trésor royal*, Paris, musée Dapper, 1990.

ÉLIADE, Mircea AND COULIANO, Ioan, *Dictionnaire des religions*, Paris, Plon, 1990.

EYO, Ekpo, *Two Thousand Years of Nigerian Art*, Department of Antiquities, Nigeria, Lagos, 1977.

FAGG, Angela, "A Preliminary Report on an Occupation Site in the Nok Valley, Nigeria: Samun Dukiya, AF/70/1", in *West African Journal of Archeology*, 1972, 2, p. 75-79.

FAGG, Bernard, "A Preliminary Note on a Series of Pottery Figurines from Northern Nigeria", in *Africa*, XV (1), 1945, p. 21-22.

Id., "A Life-Size Terra-cotta Head from Nok", in *Man*, 1956, n° 56, p. 89.

Id., "The Nok Culture in Prehistory", in *Journal of the Historical Society of Nigeria*, 4, 1959, p. 288-293.

Id., "The Nok Culture: Excavations at Taruga", in *West African Archeological Newsletter*, 1968, n° 10, p. 27-30.

Id., "Recent Work in West Africa: A New Light on the Nok Culture", in *World Archeology*, 1969, n° 1, p. 41-49.

Id., *Nok Terracottas*, Lagos, Ethnographica, 1977.

FAGG, Bernard ET FLEMING, Stuart J., "Thermoluminescent dating of a Terracotta of the Nok Culture, Nigeria", in *Archeometry*, 12, 1, 1970, p. 53-55.

FAGG, William, *Merveilles de l'art nigérian*, Paris, Chêne, 1963.

FOLORUNSO, Caleb Adebayo, "Le corridor Benue-Tchad : perspectives archéologiques", in *Vallées du Niger*, Paris, Réunion des musées nationaux, 1993, p. 116-125.

FURST, Peter, "Shamanism, Transformation, and Olmec Art", in *The Olmec World. Ritual and Rulership*, Princeton, The Art Museum, Princeton University, 1995, p. 69-81.

GILLON, Werner, *A Short History of African Art*, Penguin, London, 1991.

DE GRUNNE, Bernard, *Terres cuites anciennes de l'Ouest africain*, Louvain-La-Neuve, Institut supérieur d'Archéologie et d'Histoire de l'art, 1980.

Id., "La Statuaire Fang. Une forme d'art classique", in *Tribal Arts*, n° 2, juin 1994, p. 47-55.

DE HEUSCH, Luc, "Possession et chamanisme", in *Pourquoi l'épouser*, Paris, Gallimard, 1971.

HUFFMAN, Thomas N., "The Soapstone Birds from Great Zimbabwe", in *African Arts*, 18 (3) 1985, p. 68-73.

JEMKOUR, J. F., *Aspects of the Nok Culture*, Zaria, Ahmadu Bello University Press, 1992.

KENT REILLY III, Frank, "The Shaman in Transformation Pose : A Study of the Theme of Rulership in Olmec Art", in *Record of the Art Museum of Princeton University*, vol. XLVIII, n° 2, 1989.

KERCHACHE, Jacques, PAUDRAT, Jean-Louis AND STEPHAN, Louis, *L'Art africain*, Paris, Mazenod, 1988.

LAUWS, Henry W., "Some Reminiscences of Colonel H. W. Laws of his Arrival on the Plateau in 1903", in *Nigerian Field*, XIX, 3, 1954, p. 100-117.

LEROI-GOURHAN, André, "Observations technologiques sur le rythme statuaire", in *Échanges et Communication*, La Haye, Mouton, 1970.

LÉVI-STRAUSS, Claude, "Introduction à l'œuvre de Marcel Mauss", in Mauss, Marcel, *Sociologie et Anthropologie*, Paris, PUF, 1968.

McCALL, Daniel, "The Hornbill and Analogous Forms in West African Sculpture", in McCall, Daniel et Bay, Edna, *African Images. Essays in African Iconology*, Boston University, 1975, p. 268-324.

MEEK, Charles K., *The Northern Tribes of Nigeria*, 2 vol., Oxford, Oxford University Press, 1925.

Id., *Tribal Studies in Northern Nigeria*, 2 vol., New York, The Humanities Press, 1950.

NEVADOMSKY, Joseph, "Kemwin-Kemwin : The Apothecary Shop in Benin City", in *African Arts*, November 1988, 22 (1), p. 72-83.

PANOFSKY, Erwin, *L'Œuvre d'art et ses significations*, Paris, NRF, 1969.

PAPAIOANNOU, Kostas *et al.*, *L'Art grec*, Paris, Mazenod, 1975.

PERSON, Alain, QUÉCHON, G. AND SALIÈGE, Jean-François, "Les débuts de la métallurgie au Niger septentrional (Aïr, Azawagh, Ighazer, Termit)", in *Journal de la Société des africanistes*, 1992, 62, 2, p. 55-68.

PHILLIPS, Tom, ed., *Africa. The Art of a Continent*, Munich, Prestel Verlag, 1995.

PHILLIPSON, David W., "The Spread of Bantu Language", in *Scientific American*, April 1977, vol. CCXXXVI (4), p. 106-114.

PRIDDY, A. J., "RS/63/32 : An Iron Age Site near Yelwa, Sokoto Province: Preliminary Report", in *West African Archeological Newsletter*, 1970, 12, p. 20-32.

ROUGET, Gilbert, *La Musique et la Transe*, Paris, Gallimard, 1980.

SCHAEDLER, Karl-Ferdinand, *Earth and Ore. 2500 years of African art in terracotta and metal*, Munich, Panterra Verlag, 1997.

SHAW, Thurstan, "The Nok Sculpture of Nigeria", in *Scientific American*, 224, 3, February 1981, p. 154-166.

Id., *Nigeria. Its Archeology and Early History*, London, Thames and Hudson, 1978.

TERRY CHILDS, S. AND DE MARET, Pierre, "Reconstructing Luba Pasts", in Nooter Robert, Mary and Roberts, Allen F., *Memory. Luba Art and the Making of History*, New York, The Museum for African Art, 1996.

THOMPSON, Robert Faris, "The Sign of the Divine King: Yoruba Bead embroidered Crowns with Veil and Bird Decorations", in Fraser, Douglas et Cole, Herbert, *African Art and Leadership*, Madison, University of Wisconsin Press, 1972, p. 227-260.

UCKO, Peter J., "Penis sheaths: A Comparative Study", in *Proceedings of the Royal Anthropological Institute of Great Britain and Ireland for 1969*, 24 A-67, London, Royal Anthropological Institute, 1970.

VANSINA, Jan, "New Linguistic Evidence and the Bantu expansion", in *Journal of African History*, 36, 1995, p. 173-195.

WARDWELL, Allen, *Tangible Visions. Northwest Coast Indian Shamanism and its Art*, New York, The Monacelli Press, 1996.

WILLETT, Frank, "A Missing Millenium ? From Nok to Ife and beyond", in Bassani, Ezio, ed., *Arte in Africa*, Modena, Panini, 1984, p. 87-100.

Id., "L'archéologie de l'art nigérian", in Martin, Hubert, Féau, Christian and Joubert, Hélène, *Arts du Nigeria*, Paris, musée des Arts d'Afrique et d'Océanie, 1997, p. 23-43.

WILLIAMSON, Kay, "Le pedigree des nations: linguistique historique au Nigeria", in *Vallées du Niger*, Paris, Réunion des musées nationaux, 1993, p. 267-270.

PICTURE CREDITS

Photos by Hugues Dubois: numbers 1, 3, 4, 5, 7, 8, 9, 10, 11, 12, 13, 15, 16, 17, 18, 20, 21, 22, 23, 24, 25, 27, 29, 30, 31, 32, 33, 35, 36, 38, 39, 40, 41, 42, 43, 44, 45, 46, 47, 48, 49, 52, 53, 54, 55, 56, 57, 58, 59, 60, 61, 62, 63, 65, 66, front cover, back cover.

Documentation Philippe Guimiot, photos by Roger Asselberghs: numbers 26, 37, 50, 51.

Photos by Roger Asselberghs: numbers 6, 34 and Fig. 3, 4, 5, 8, 9.

Photos by Pierre Alain Ferrazini: numbers 28, 64.

Photos by Louis Tirily: Fig. 1, 2, 7.

Photos by Rolf Wolfsberger: numbers 2, 14.

All rights reserved: number 19, Fig. 6 and pages 52 left, 54 right, 56, 60, 64, 115.

Translator
Lisa Davidson
Copy editor
Elizabeth Ayre, Tina Isaac
Design and layout
Sophie Zagradsky
Illustrations and maps
Socapi, Mons
Photoengraving
Musumeci

Printed by Musumeci,
Quart, Italy, October 1998.